COVER ILLUSTRATION: Guercino, *Cumaean Sibyl with a Child Angel* (Cat. No.37)
FRONTISPIECE: Detail from *Diana and Callisto*, by Annibale Carracci (Cat. No.17)

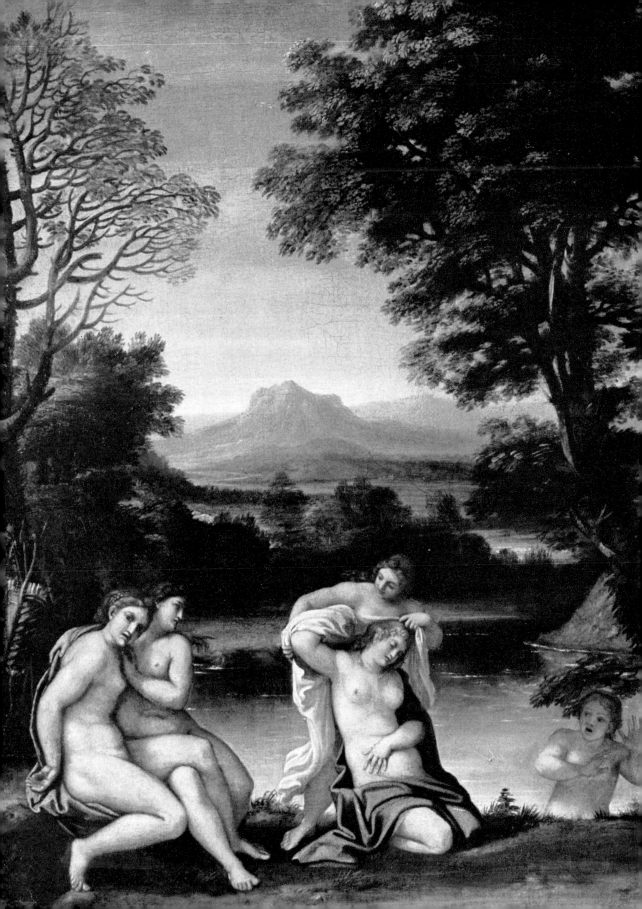

England and the Seicento

A Loan Exhibition of Bolognese Paintings from British Collections

6 November – 7 December 1973

In aid of the National Art-Collections Fund 1903–73

THOS. AGNEW AND SONS LTD

43 Old Bond Street, London W1

OPENING TIMES
Mondays–Fridays 9.30–5.30 pm, Thursdays until 7 pm
Saturdays 9.30–1.00 pm

Catalogue by Clovis Whitfield

Foreword

For the first time, as far as I know, London is being given the chance of seeing a representative collection of Bolognese paintings. All of them come from British collections and most have been hanging in great houses for a hundred and fifty years or so. The Exhibition shows once again how the taste and discrimination of our Art Lovers, this time in a lesser known field, have enriched our heritage.

There are three things that particularly strike me. First, the generosity of owners in parting with their pictures. Secondly, Agnew's diplomacy in persuading them to do so and their skill in producing an Exhibition of this calibre. And thirdly, that all the proceeds of the Exhibition – entry fees and catalogues – are being allotted by Agnew's, without deduction of expenses, to the National Art-Collections Fund. As Chairman of the Fund I thank them for a magnificent 70th birthday present.

It is becoming more and more difficult for the average person to form a private collection so that communal collecting may become the pattern. It gives great satisfaction to be a patron of the Arts and to collect for all beholders, and this you can do by joining the National Art-Collections Fund. The Fund badly needs more members and, if you are not one already, you will find a form of application for membership at the back of the catalogue.

November 1973

ANTONY HORNBY
Chairman of the National Art-Collections Fund

The National Art-Collection Fund

The National Art-Collections Fund is still an entirely independent organisation. It receives no subsidies, no grants, and relies entirely on private subscriptions and bequests. However, members receive for their subscription far more than just the satisfaction of having contributed to the objects of the fund. Private views (recently of the Tutankhamun exhibition at the British Museum), evening parties, foreign visits, access (through the generosity of its members) to private collections, free admission to art galleries and museums, if and when charges start being imposed, are all for the members of the Fund.

The Fund is run by an executive committee under the current chairmanship of Sir Antony Hornby and it can in addition draw advice from members of an advisory panel when necessary. It receives many requests for support, over half from provincial museums and art galleries anxious to acquire works of local importance.

In 1972 the Fund made grants amounting to £158,400; (this very high figure includes of course the £100,000 given for the Titian *Death of Actaeon*). More than £110,000 of this sum went to London art galleries and museums and £48,000 to those outside London. But at the end of 1972 membership stood at only 10,000.

By the end of last year nearly 2,500 items had been secured with the help of the Fund, but as one entry can mean many items, the actual number of works of art acquired is many more.

The National Art-Collections Fund is growing, the National Art-Collections Fund needs to grow more, and it greatly needs a younger membership as well as a much larger one.

The subscription is £3·00 per year minimum, husband and wife joint membership £5·00. There is also a life membership scheme of £75 per person. Under the terms of the 1972 Finance Act, gifts and bequests in favour of the Fund are exempt from Estate Duty and Capital Gains Tax up to any amount.

Those wishing to join should apply to the secretary: Miss Mary Shapland, National Art-Collections Fund, Hertford House, Manchester Square, London, WIM 6BN.

Introduction

For two centuries after their lifetimes, the artists in this exhibition were held among the very greatest masters. For many a visitor to Rome, Domenichino's *Last Communion of St. Jerome* was the supreme achievement in paint after Raphael's Transfiguration, and the vault of the Farnese Gallery a text for all art students. From the work of the Bolognese painters were culled the very principles of art for academies that sprang up the breadth of Europe in emulation of the Carracci's Accademia degli Incamminati. Their grandest productions were brought to England to adorn the finest interiors of the eighteenth century; their cabinet works changed hands at prices that even now seem heady. The tradition of landscape painting they initiated took root readily in this country, and shaped the vision of a Capability Brown, altering with notions of the Picturesque the very profile of the English landscape. But the last century turned against the age they come from, and consigned them to oblivion as a vulgar and bad parody of an earlier period. 'No amount of rearrangement will infuse life' wrote even Berenson of a school he otherwise ignored. Today, it is no longer necessary to argue the fallacy of the Eclectic interpretation; it has been critically discredited, and as much again by the cleaning of many of the works, revealing subtleties of colour that have been hidden since their own century. A series of major exhibitions at Bologna have given a full review of many of the greatest artists. Many of the paintings shown at these great exhibitions, of which the most recent was the *Guercino* in 1968, came necessarily from British collections. It is thus particularly appropriate that a special exhibition should be devoted to them here at this time.

The supreme achievement that is constituted by the decoration of the Farnese Gallery in Rome was based in Annibale Carracci's career on the solid foundations of his Bolognese innovations, tempered by the impact of classical antiquity and the paintings he saw in Rome. As a scheme of decoration, it was of seminal importance for Baroque illusionism, like that of Lanfranco and Pietro da Cortona, later in the century. It was admired also, but interpreted in a rather different way, by the painters in the "classical' tradition, like Reni, Domenichino, Sacchi and Poussin. But Annibale was not the sole originator of all this pictorial innovation. It was a school that he

had founded together with his cousin Lodovico and his brother Agostino, in Bologna sometime in the 1580s, and one which came to be known as the Accademia degli Incamminati. Progressive it certainly was, and a number of circumstances favoured its inventive character.

A new attitude, hostile to the involved allegory and complicated virtuosity of Mannerist painters, had been foreshadowed by the deliberations of the Council of Trent. Although Counter-Reformation authors like Gilio and Paleotti seem by their style to be out of touch with the practical needs of painters, religious themes came to be illustrated explicitly, simply and expressively, and the very return to nature that the Carracci sought can itself be regarded as following the spirit of the attempted reform. They found patrons who could share, understand and encourage new ideas, and in doing so they found new places for a variety of artistic genres – schemes of decoration with landscapes, history paintings with small figures, illustrations from literary sources like Tasso and Ariosto. Together with these patrons, they shared an admiration for classical antiquity. But what was new to their generation was that they could also look back with a common admiration for the work of *painters* of previous generations, an admiration quite different from the usual course of stylistic influence. The course of Annibale's career illustrates at every turn his willingness to learn – from Correggio, from Venetian painting, from classical art, from the High Renaissance, from his intellectual friends, without producing work that could be termed 'derivative'.

As a family, the Carracci were of different characters, and complemented each others' artistic creativity. The work of the school as a whole is, however, coloured by the original insistence on study from nature. This is illustrated especially in the early Annibale, where some of the paintings (as well as the drawings) have no more serious theme than the visual appearance of the subjects themselves. So far as preparation for figure-compositions is concerned, study from nature is a practice which goes back of course to Raphael; but in Bologna the Carracci carried this logically further, to include all aspects of preparation for painting. The results made a complete contrast with the contrived compositions and artificial colouring of contemporary Mannerist painters. The Carracci's naturalism brought new meaning to religious themes, as it also brought appreciation of the poetry of new sides of Nature itself.

Annibale's name is naturally the most prominent among the Carracci, but Lodovico and Agostino were also separately influential. Lodovico remained in Bologna all his life (although he certainly travelled, even briefly to Rome after the completion of the Farnese Gallery) and continued the school after his cousins' departure from Bologna. It was his painting that was thus the starting point for Lanfranco and Badalocchio, and he continued to be an influential figure in the early seventeenth century, notably with painters like Tiarini whose background was entirely Central Italian. Lanfranco's sense of scale, as much as Badalocchio's modulation of light, has its origins in Lodovico's in the last decade of the sixteenth century. 'The pictures of Agostino are rare, for his time was much occupied in delivering lectures, and in engraving'. So wrote Alan Cunningham in 1840; it is still difficult to see his personality fully, although his contribution both as a painter and an intellectual is almost certainly underestimated.

The great period of Bolognese painting begins with the inauspicious declaration, in the name of the Council of Trent, that painting was a 'materia da religiosi'. Fitting it may have been for clerics to interest themselves in the arts, but it was hardly fruitful for a Gilio, or a Gabriele Paleotti, Bishop of Bologna, to lay down how a painter should treat a particular subject. But one exceptional cleric who may have taken a lead from Paleotti (whose treatise on painting was published in Bologna in 1581) was Giovanni Battista Agucchi, who had a distinguished career in the service of the Church. It seems as though Agucchi was the sort of person who could mediate between the involved world of sixteenth century literacy – the world of emblems, mottoes and devices – and the painter. Bolognese himself, he was close to the Carracci, and then to some of their pupils in Rome, notably Domenichino. As major-domo to Cardinal Pietro Aldobrandini, Clement VIII's most successful and powerful nephew, Agucchi was able to patronize the artists of his choice, and he kept in close touch with them as they were painting. A connoisseur of painting, who had in his care one of the finest collections of sixteenth century pictures of all schools, he found that he could communicate with artists, who came to share his ideas and enthusiasms. Intellectual ideas certainly became important for Annibale after he came to Rome – even though he was previously averse to them. We can see for example a theological extension of subject matter in his *Il Silenzio* (Madonna and sleeping Child with St. John; H.M. the Queen, Hampton

Court), where the Virgin's admonition to St. John not to disturb the sleeping Child can be read as implying that He should not be woken to His Passion before time. This would have appealed to Agucchi, just as the similar extension of subject-matter in Domenichino's *Madonna della Rosa* (No.26). There is a more personal note perhaps in Annibale's *Domine, Quo Vadis* now in the National Gallery, where the St. Peter must be a conscious allusion to the Pietro Aldobrandini for whom it was painted. But it is known that Agucchi also prepared more elaborate programmes for paintings, some with literary subjects chosen for their particular appropriateness to a patron, and this is of great importance in anticipating the nature of Seicento patronage, which drew a great deal on literary sources such as Ariosto and Tasso. Agucchi is in this respect a forerunner of such individuals as Poussin's patron Cassiano dal Pozzo, introducing the pictorial arts to what might have remained a literary section of the public, with a sterile concentration on the ingenuity of devices and mottoes. With Agucchi also originates the theory of art that finds a restatement in Bellori later in the century, and is drawn upon by the academic tradition starting with the French Académie Royale. This, as Mr. Mahon has shown (*Studies in Seicento Art and Theory*, 1947) was an important legacy; but it is likely that the relationship that existed between Agucchi and his Bolognese friends in Rome was far more creative and reciprocal than the formal academic tradition would suggest.

From the point of view of the history of collecting, the paintings of the Bolognese school make a fascinating study. Enough is known about the illustrious patrons of the seventeenth century to realize what competition there was for the works of a Guido or a Guercino in their own time. On the other hand, many of the schemes of decoration they completed were dismantled, and in some cases fashion changed. In Florence we hear of Pietro da Cortona relegating a Guido Reni to a less prominent position in the Medici collection, as early as the middle of the century; opportunities such as this were seized upon by collectors from elsewhere. It was natural with the founding of the French Académie Royale that many Bolognese works should be imported into France, and indeed their presence in the Royal collection, and in the possession of many private collectors, is mentioned by Bellori and Félibien. Domenichino was the one living artist for whom it was said Poussin had an admiration, and French links with Italian art were strong in the seventeenth century. Many of the Seicento paintings in

seventeenth century French collections ended up in the Orléans collection in the eighteenth, and then it was not by chance that the Italian part of the collection was sold in London in 1798/99.

During the whole of the eighteenth century indeed English collectors had turned in earnest to the Bolognese painters. It was true that Raphael, Michelangelo and Correggio were thought the most highly of, but in that field it was well-nigh impossible to find genuine and recognized works. Guido, Guercino, the Carracci, Albani, Domenichino – the names were the hallmark of a good collection, and their classical refinement was well at home in the restrained and yet magnificent interiors of the English eighteenth century. There was no more perfect intellectual and visual complement to Lord Burlington's Palladianism than a work like Domenichino's *Madonna della Rosa* (No.26) which then hung at Chiswick House. Some of the paintings shown in this exhibition come precisely from those eighteenth century interiors for which they were first purchased – the Guidos from Holkham and Kedleston, the magnificent Guercino of *Erminia finding the Wounded Tancred* that the 5th Earl of Carlisle bought to adorn Castle Howard. These importations were in themselves influential on the course of English painting, notably with the grand compositions of works like Guercino's *Cumaean Sibyl* (No.37). Gavin Hamilton, the plates of whose formative *Schola Italica Picturae* (1773) were over a quarter of Bolognese works, had particularly felt the impact of Bolognese classicism. It was characteristic that Hamilton, having bought in 1768 Guercino's *Samian Sibyl* for the 1st Lord Spencer, should later paint a portrait of Lady Hamilton in such a guise. Gavin Hamilton's neo-classicism belongs to the early phase of the style in England, based on the solidity of Bolognese forms as opposed to the relative prettiness of later in the century. Contact with the monumental compositions of Bolognese painting had its impact elsewhere in British eighteenth century art, notably in the field of portraiture.

The Italian churches and private collections were the mine from which English aristocrats on the Grand Tour drew, spending vast fortunes on works they could be certain were genuine. Agent/dealers like Sir Robert Strange, Gavin Hamilton, Alexander Day, William Buchanan and many others scoured the country for churches that would be prepared to sell their treasures for princely sums and a copy to replace the original, cajoled the Aldobrandini, Giustiniani or Borghese into parting with yet another gem.

So the Bolognese Seicento found itself concentrated in British collections by the middle of the nineteenth century; the disfavour into which it had fallen fifty years later has ironically meant that perhaps more has stayed in this country, in private collections at least, than would otherwise have been the case.

The long history that the Bolognese school has of intense admiration in several countries has carried with it its own problems of attribution. The personalities of many of the lesser artists are difficult to distinguish, and the absence of documentation has tended to cause an elision between some artists' work, as for example in the case of Annibale and Agostino Carracci, where difficulties of attribution are most obvious in the field of drawings, but also apply to paintings. The English eighteenth century had a great enthusiasm for Bolognese landscape, but no-one had heard of artists other than Annibale Carracci and Domenichino practising this genre. William Buchanan was conscious of this when he wrote about it in 1824 'Much confusion has often been created in the changing of names, sometimes from interested motives, sometimes for the sake of gratifying the caprice of the owner, or the fashion of the day'. It was no wonder that the legend grew up that the Earl of Burlington, to secure a genuine Domenichino, had donated a set of marble columns to a church in Rome. It is exciting to recreate a taste that provoked such thoughts, and was as perfect a complement to the eighteenth century as it was innovatory in its own.

CLOVIS WHITFIELD

We would like to record our grateful thanks to all those who have helped in the preparation of this Exhibition, but especially to Mr. Denis Mahon, who, apart from lending so generously from his collection, has made valuable suggestions at all stages; to Professor Stephen Pepper, who has contributed information relating to the paintings by Guido Reni; to Dr. Kenneth Garlick, for details of the paintings from Althorp, and to Mr. Frank Simpson, of the Mellon Centre.

Lenders

The Most Hon. The Marquess of Aberdeen, c.b.e., t.d.

Thos. Agnew and Sons Ltd.

The Trustees of the Basildon Pictures Settlement

His Grace The Duke of Buccleuch and Queensberry

The Christie Estate Trust

The Devonshire Collection, Chatsworth: The Trustees of The Chatsworth Settlement

The Glasgow Art Gallery

The Castle Howard Collection

The Most Hon. The Marquess of Lansdowne

The Trustees of The Earl of Leicester, m.v.o.

Denis Mahon, Esq., c.b.e.

His Grace The Duke of Northumberland, k.g., t.d.

The Viscount Scarsdale, t.d.

The Earl of Shelburne

The Norton Simon Foundation, Los Angeles

The Earl Spencer

His Grace The Duke of Sutherland

His Grace The Duke of Wellington, m.v.o., o.b.e., m.c.

The Earl of Yarborough

The York City Art Gallery

and those who wish to remain anonymous

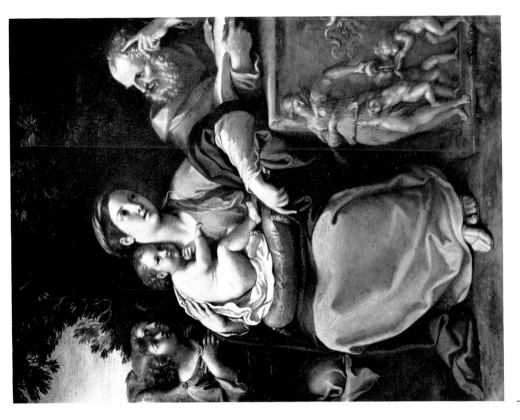

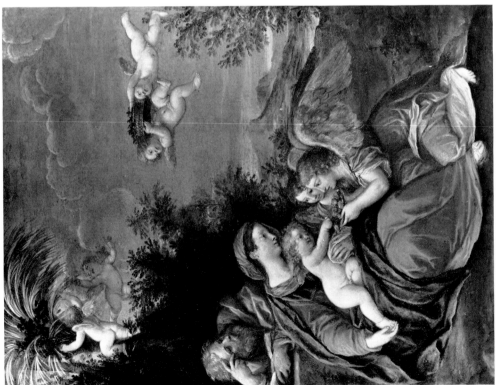

1

2

Francesco Albani 1578–1660

1 *Holy Family*

Copper, $14\frac{3}{4}$ by $11\frac{1}{4}$ inches, 37·5 by 28·5 cms

Collections: Sophie Aufrère, who in 1770 married Charles Anderson Pelham, later Lord Yarborough, and by descent.

Exhibited: Bologna, *L'Ideale Classico e la Pittura di Paesaggio*, 1962, No.36.

This early work must date from the period when Albani was most closely in contact with Annibale Carracci. After the onset of the latter's illness in 1604/05, Albani took over the direction of some of the commissions the studio had in hand. The features of the composition echo Annibale's paintings, but already possess that softness of contour that distinguishes his style.

A version of the composition was formerly in the Orléans Collection from at least 1727, previously in the collection of M. de Nancré. It was acquired at the Orléans sale in London in 1798/99 by Lady Lucas, but has been lost sight of since 1905, when it was sold.

Lent by the Earl of Yarborough.

2 *The Holy Family*

Copper, $16\frac{3}{4}$ by $12\frac{1}{4}$ inches, 42·5 by 31 cms

Collections: Sir Richard Worsley of Appuldurcombe, whose niece and heiress married the 1st Earl of Yarborough in 1806, and by descent.

Exhibited: Bologna, *L'Ideale Classico e la Pittura di Paesaggio*, 1962, No.53.

This much later (1635/45) *Holy Family* illustrates the path of Albani's development. Never as serious a painter as Domenichino or Guido Reni, his charm and delicacy are fully brought out here, a genuinely creative work which gives a new flavour to this Bolognese theme. The composition inspired an etching by G. F. Grimaldi, in which the figure group is repeated, but set in a different landscape.

Lent by the Earl of Yarborough.

Sisto Badalocchio 1585–after 1621

3 *Rest on the Flight into Egypt*

Canvas, 17½ by 24 inches, 47·4 by 62·7 cms
Collection: Agnew's, 1959.
Exhibited: Bologna, Palazzo dell'Archiginnasio, *Maestri della Pittura del Seicento Emiliano*, 1959, No.120.
Literature: Dwight Miller, *Seventeenth Century Emilian Painting at Bologna*, The Burlington Magazine, Vol.101, 1959, p.209, Fig.7.

It is possible that Sisto Badalocchio was given his first artistic training by Agostino Carracci in Parma, where the latter worked from 1600 until his death in 1602. Soon afterwards we find Sisto documented as a fellow-lodger with Lanfranco in Annibale's house in Rome, and while he always retained Parmese characteristics, the Carracci made the strongest impact on his style. A number of his pictures are variations on originals by Annibale, and Sisto himself acknowledged the importance of his example in the dedication (1607) of a series of prints after the Old Testament scenes by Raphael in the Logge of the Vatican.

But Sisto's interpretations of Annibale's compositions are always very personal; he remained close to his compatriot Lanfranco, and, though working to a smaller scale, was also always conscious of the art of Correggio. The classical forms of the late Annibale are softened and suffused with a gentle touch.

The relationship of the present *Rest on the Flight* to forms in the Vienna *Pietà* by Annibale (1603/04) has already been noted (in the catalogue of the 1959 Bologna exhibition). Not only the combination of figures and landscape reflect the work of his teacher, but also the juxtaposition of a large foreground figure with one in the middle distance stems from Annibale's ideas of scale. This genre of painting enjoyed great success in the Seicento as, among other many *Flights into Egypt*, P. F. Mola's painting (No.39) shows.

Lent anonymously.

Sisto Badalocchio 1585–after 1621

4 *The Three Maries at the Tomb*

Panel, 18½ by 24 inches, 47 by 61 cms
Collection: Acquired in the late eighteenth century by Thomas Talbot.

The composition is a free interpretation of Annibale's painting, now in the Hermitage at Leningrad, which was once in the collection of G.B. Agucchi (see No.24). Sisto has transformed Annibale's austere forms, which fill the painting to the edge of the frame, into another genre in which landscape, and the setting in general, play a greater part. He was able here, as in his contribution to the Aldobrandini lunettes, to exploit the impact of light against darkness with a caressing rather than sculptural touch.

Lent anonymously.

5 *Tancred and Clorinda*

Canvas, 47 by 61½ inches, 119·5 by 156·2 cms
A pair with No.6
Collections: Pietro Camuccini; bought by the 4th Duke of Northumberland with the Camuccini collection in 1856.
Exhibited: British Institution, *Old Masters*, 1858, No.46 (as by Agostino Carracci); Royal Academy, *Holbein and other Masters*, 1950/51, No.307.
Literature: G. F. Waagen, *Treasures of Art . . .* , Vol.IV, Supplement, 1857, p.470; E.K. Waterhouse, *Tasso and the Visual Arts*, Italian Studies, III, 1947, p.160; Denis Mahon, *The Seicento at Burlington House (II)*, The Burlington Magazine, Vol.93, 1951, p.85ff, Fig.23; Catalogue, *I Carracci, Bologna*, 1956, under No.115; L. Salerno, *Per Sisto Badalocchio e la cronologia del Lanfranco*, Commentari, 9, 1958, p.44ff.
The subject of Tancred baptizing the dying Clorinda is taken from Tasso's *Gerusalemme Liberata*, Canto XII, stanze 67–69.

As Denis Mahon first recognized in 1951, this *Tancred and Clorinda* is related to another version in the Galleria Estense in Modena. The latter is more Annibalesque, suggesting that it must have been painted in Rome, while this picture would date after Sisto's return to his native Emilia. The pendant, *Rinaldo and Armida* (No.6), is hitherto unpublished, although it was exhibited once during the nineteenth century.

First published in 1581, Tasso's *Gerusalemme Liberata* began to be used as subject-matter by painters in Rome towards the end of the sixteenth century. At a time when connoisseurs like G. B. Agucchi came to appreciate painting for its own sake, it was natural that themes should be selected that were poetical in subject as well as lyrical in appearance. The complex allegories and conceits of the Mannerist era

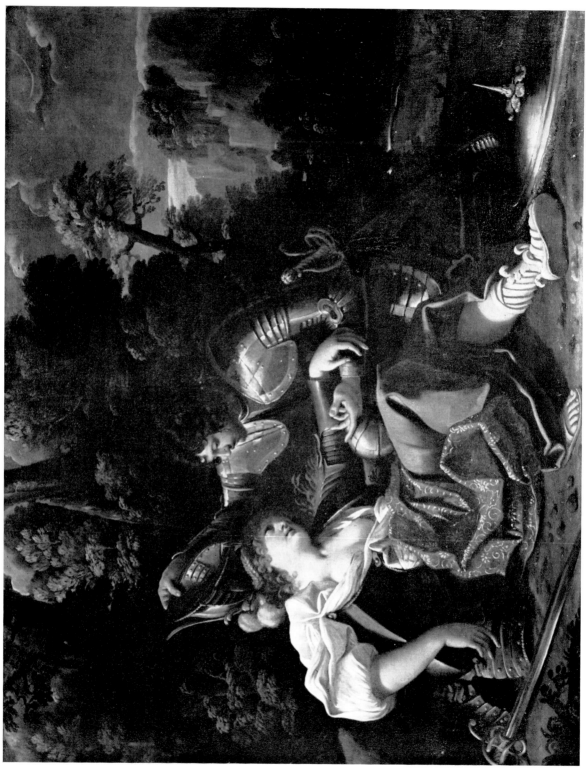

were replaced by themes that were appropriate to the personality of the patron –
Agucchi for example commissioned an *Erminia and the Shepherds* because this led him
to an inner peace by analogy with Erminia's seeking a rustic refuge.

The composition of the *pendant* (see No.6) goes back to Annibale's *Rinaldo and
Armida*, now in the Galleria Nazionale di Capodimonte at Naples, which originally
decorated the garden pavilion at the Palazzo Farnese. Particularly appropriately,
in view of Tasso's description of the enchanted garden in which Rinaldo and
Armida are espied by the soldiers, the architecture in the background of Annibale's
painting is that of the Palazzo Farnese itself. Together with Annibale's painting
(completed with studio assistance) these pictures are among the earliest pictorial
representations from Tasso.

Lent by the Duke of Northumberland, K.G., T.D.

Sisto Badalocchio 1585–after 1621

6 *Rinaldo and Armida*

Canvas, 47 by 61½ inches, 119·5 by 156·2 cms

Collections: Pietro Camuccini; bought by the 4th Duke of Northumberland with
the Camuccini Collection, 1856.

Exhibited: British Institution, *Old Masters*, 1859, No.36 (as Agostino Carracci).

The subject of Rinaldo and Armida is taken from Tasso's *Gerusalemme Liberata*,
Canto XVI, stanze 18–23.

See notes to the *pendant*, No.5.

Lent by the Duke of Northumberland, K.G., T.D.

Guido Cagnacci 1601–1681

7 *Lucretia*

8 *Cleopatra*

Canvas, 50 by 39½ inches each, 127 by 100·3 cms
Collections: Robert, 2nd Earl of Sunderland, and by descent at Althorp.
Literature: Robert Dibdin, *Aedes Althorpianae*, 1822, pp.17/18.

We are grateful to Dr. Kenneth Garlick, who is working with Professor E. K. Waterhouse on the catalogue of the collection of pictures at Althorp to be published by the Walpole Society, for information about these paintings by Cagnacci. From the seventeenth century collection of the Earl of Sunderland, they are listed in a MS inventory of 1746 as Nos.174 and 206 and as 'after Guido'. In the list of 1750, only the *Cleopatra* is mentioned, as by Reni and hanging in the Little Parlour. Apart from Dibdin's mention of them in the *Aedes Althorpianae* (as by Reni), they are listed in the 1851 catalogue, this time as by Cagnacci.

Guido Reni's pupil Cagnacci worked in his studio before 1634, after which date the latter established himself in Rimini. Around 1650 he worked in Venice, and later he settled in Vienna and worked at the court of Leopold I. His style is a very personal one, yet blended with reminiscences of very varied sources. The pair from Althorp are of subjects favoured by Reni, and often painted by Cagnacci also. Instead of the formal refinement of the late Reni however, there is here more emphasis on the sensuality of female form, an element also apparent in the two scenes of *Gyges and Candaules* (Nos.9, 10). The latter show more of his indebtedness to the Caravaggesque tradition – especially that of Northerners working in Italy – but light is used to reveal sensual form rather than for realistic impact.

Lent by the Earl Spencer.

Guido Cagnacci 1601–1681

9 *Candaules reveals the Queen's Nakedness to Gyges*
10 *The Queen pointing out the Sleeping Candaules to Gyges*

Canvas, each 60 by 58½ inches, 152·3 by 148·6 cms
Collection: L. W. Neeld, Grittleton House, Chippenham; Mrs John Bourne.

According to Herodotus and Justin, Candaules, the last Heracleid King of Lydia, took great pride in his wife's beauty and insisted on showing her naked, though without her knowledge, to his favourite officer Gyges. Gyges was seen by the Queen when leaving her room, and she summoned him the following day to offer him the choice of death or his consent to murder Candaules and take for himself the kingdom and her hand. He chose the second course, and became the founder of the dynasty of the Mermnadae, about 715 BC.

These pictures are from a set of four illustrating scenes from the story of Gyges and Candaules.

See also notes to Nos.7–8

Lent anonymously.

Dionisio Calvaert about 1540–1619

11 *Madonna and Child*

Copper, 11 by 8½ inches
Collection: Mrs E. Forbes Tweedie
Exhibited: Agnew's, *Small Pictures for Small Rooms*, 1964, No. 31.

The expatriate Flemish artist Denis Calvaert is an important figure from the point of view of Bolognese Seicento painting, since it was in his studio that Guido Reni, Domenichino, Albani and many others had their first artistic training. His was the most active, and by far the largest, painting school in Bologna in the 1580s, and naturally some of his studio practices were taken over by the Carracci. Considerable use was, for instance, made of drawings and engravings after other artists' work. Although Annibale's naturalism was a reaction against the mannerism and artificial colouring of Calvaert and others, he continued the genre of small paintings on copper, which the latter seems to have originated and of which the exhibited painting is an example. This was of course the format of many of the cabinet pieces from Annibale's school in Rome.

The composition of this *Madonna and Child* derives from a famous and much copied votive fresco, formerly in the church of the Blessed Virgin della Ghiara at Reggio Emilia, painted on Lelio Orsi's design. A very damaged drawing claimed to be this design, and dated 1569, is preserved at that church.

Lent anonymously.

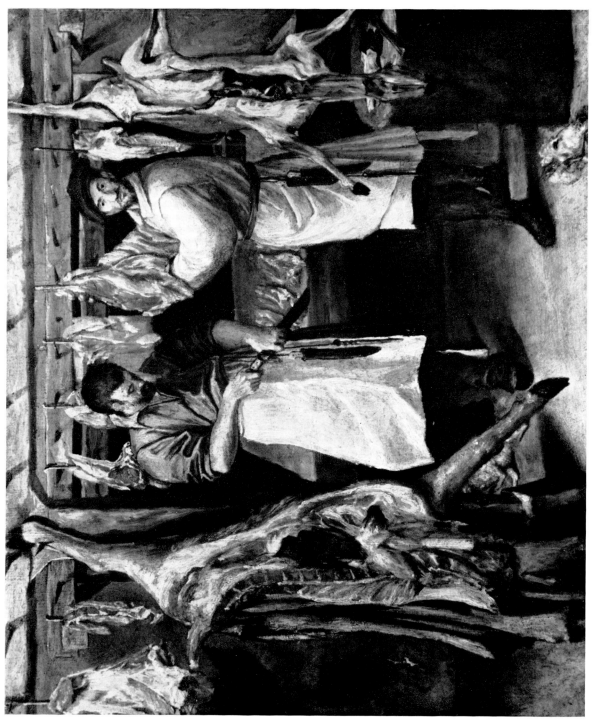

Annibale Carracci 1560–1609

12 *A Butcher's Shop*

Canvas, 23½ by 28 inches, 59·9 by 71·4 cms

Exhibited: Newcastle-on-Tyne, Hatton Gallery, *The Carracci*, 1961, No.196.

Literature: M. Jaffé, *The Carracci at Newcastle-on-Tyne*, Burlington Magazine, 104, 1962 p.27, Fig.30; D. Posner, *Annibale Carracci*, 1971, Vol.I, pp.15/16; Vol.II, p.4, No.5.

Annibale's painting is based on the solid foundation of observed fact, and nowhere is this more apparent than in the early works of genre character. They stand apart from the Passerottian tradition in which they seem to start by the absence of sentiment and narrative; they represent the side of Annibale which was so averse to theorizing and artificiality in subject-matter. Like Raphael, who made studies from the life in preparation for compositions, he sought to go to source for every detail of his work. This tendency is as evident in the genre paintings as in his landscape studies from nature.

This painting is related to the much better-known painting at Christ Church (J. Byam Shaw, *Catalogue of Paintings . . .*, 1967, No.181).

Lent by the Marquess of Aberdeen, c.b.e., t.d.

Annibale Carracci 1560–1609

13 *A Young Man in a Plumed Hat*

Canvas, 25¼ by 20¾ inches, 64·4 by 52·7 cms

Collection: at Montagu House in 1770, and by descent to the present owner.

Exhibited: City Art Gallery, Manchester, *Between Renaissance and Baroque*, 1965, No.247.

Literature: *Catalogue of Pictures at Montagu House*, 1898, No.64. D. Posner, *Annibale Carracci*, 1971, Vol.I, p.21, Vol.II, p.10, No.17.

Shown in 1965 as a work by Taddeo Zuccari, it has been argued convincingly that this is a work by Annibale of around 1584. It shares with the early genre paintings a vigorous handling, and the modelling of the flesh is close to that of pictures like the *Boy Drinking* (No.14).

Lent by the Duke of Buccleuch and Queensberry.

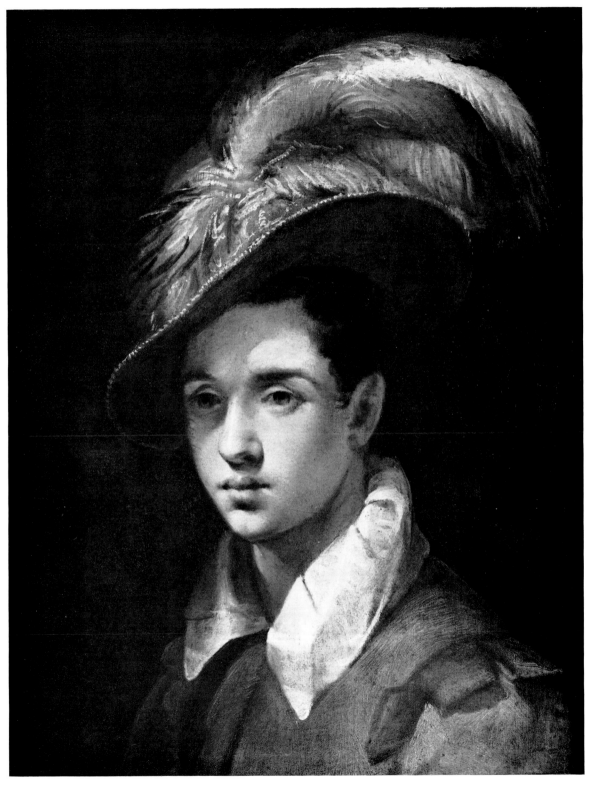

13

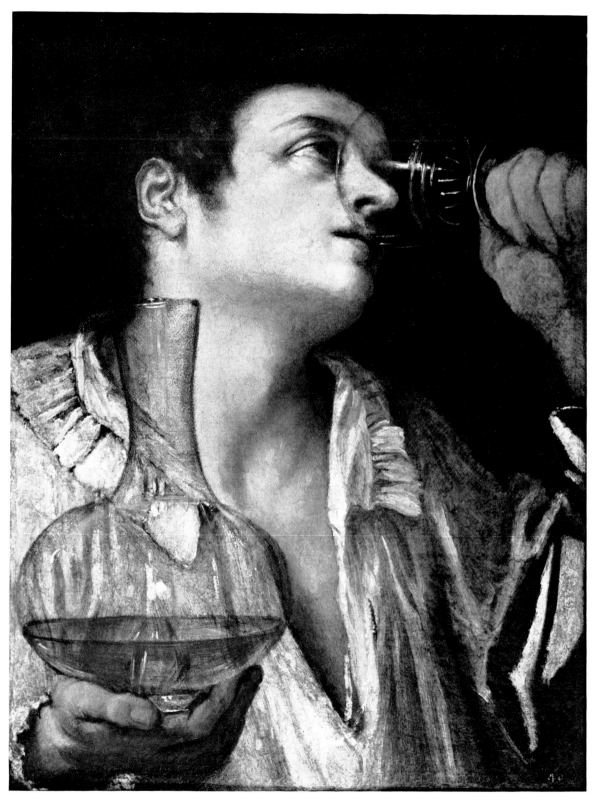

14

Annibale Carracci 1560–1609

14 *A Boy Drinking*

Canvas, 20¾ by 16⅛ inches, 53 by 41 cms

Collections: Borghese collection (1693; the earlier inventory No.403 is still partially visible at the base of the painting); acquired by R. Fagan from that collection; Sir A. Hume, London (by 1817); Earl Brownlow; his Sale, 3 May, 1929; Agnew's 1955; Dr. Robert Emmons.

Exhibited: British Institution, *Old Masters*, 1816, No.38 (as Titian); Bologna, Palazzo dell'Archiginnasio, *I Carracci*, 1956, No.50.

Literature: Sir A. Hume, *Notices of the Life and Works of Titian*, 1829, p.49; G. F. Waagen, *Treasures of Art . . .*, 1854, II, pp. 203, 314; H. Voss, *Die Mostra dei Carracci . . .*, Kunstchronik, IX, 1956, p.320; Paola della Pergola, *L'Inventario Borghese del 1693*, Arte Antica e Moderna, 1964/65, p.455, No.260; D. Posner, *Annibale Carracci*, 1971, Vol.I, pp.19/20, Vol.II, p.5, No.9.

This is the best conserved of a number of paintings of the same subject, all of which date from early in the artist's career, perhaps around 1583. Its previous attribution to Titian only illustrates the relevance of Venetian painting for Annibale. Like the *Bean-Eater* in the Colonna Gallery in Rome, this painting has as its subject nothing more pretentious than the direct study of appearances. The continual study of his surroundings by Annibale is well attested to by his contemporaries, as well as by the immediacy of his surviving studies from life.

Lent anonymously.

15 *Self-Portrait*

Canvas, laid on panel, 17⅛ by 13¼ inches, 43·5 by 33·7 cms

Collection: Harold Bompas

Literature: D. Posner, *Annibale Carracci*, 1971, Vol.II, p.7, No.61 bis.

This self-portrait is dated by Posner to around 1590/91, and to the same moment as the *Self-Portrait* in the Uffizi. Though the features are not necessarily those of the same person, the quality of the handling is indeed that of Annibale himself.

Lent anonymously.

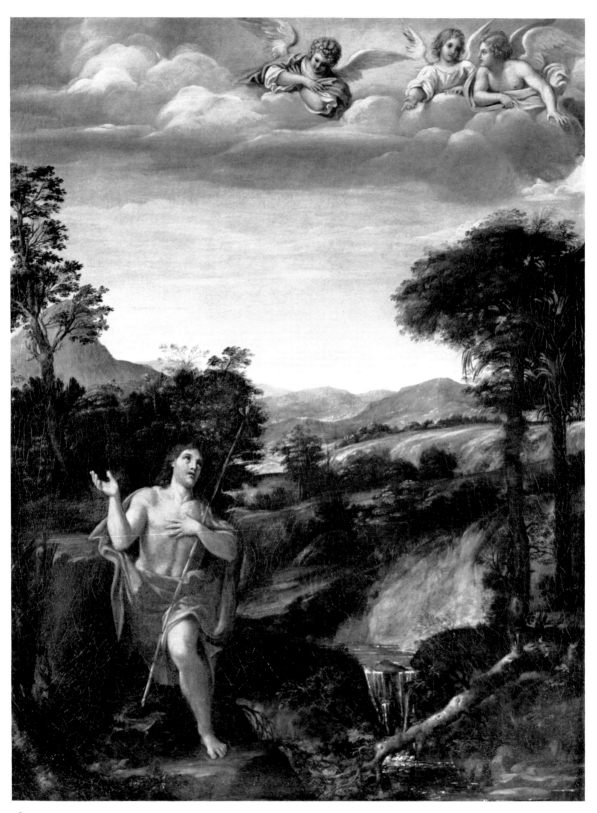

Annibale Carracci 1560–1609

16 St. John the Baptist in a Landscape

Collections: Baron Vincenzo Camuccini (1771–1844), Rome; bought with the Camuccini collection by the 4th Duke of Northumberland in 1856; by descent at Alnwick until 1953; Agnew's.

Exhibited: British Institution, *Old Masters*, 1858 (as by Domenichino); Vienna, Kunsthistorisches Museum, May–July 1955; Birmingham, *Italian Art*, 1955, No.31; Bologna, *I Carracci*, 1956, No.73; Royal Academy, *Italian Art and Britain*, 1960, No.383.

Literature: E. Platner & al., *Beschreibung der Stadt Rom.*, III, part 3, 1842, p.270; G. F. Waagen, *Treasures of Art* . . ., IV, Supplement, 1857, p.470; D. Sutton, Country Life, 118, 8 Sept. 1955, p.493 (repr.); D. Mahon, Gazette des Beaux-Arts, 1957, pp.283–284; D. Posner, *Annibale Carracci*, 1971, Vol.I, p.117/18, Vol.II p.38, No.88.

A version by Albani (Ringling Museum of Art, Sarasota) of some years later might indicate that this picture was painted in Rome; if so, it must have been about 1595. Donald Posner has suggested that it might be identifiable with a painting of the same subject in the Borghese inventory of 1693.

In this upright composition Annibale is still searching for the balance between foreground and background that was to be the key to this genre of history painting 'con figure piccole'. The principles he evolved are echoed in Giulio Mancini's *Considerazioni sulla Pittura* (of about 1621; ed. 1956, Vol.I, p.114), where the writer talks of the perfect landscape ('paese perfetto') being divided into a foreground, middle ground and a distance:

'In the foreground the eye encounters the vehemence of reality . . . The middle distance is the place for showing large things, like towns, lakes, seas and other things to a small scale ('in quantità piccola') and refracted colour . . . (thus the eye) sees large and delightful objects in a small compass.'

Such ideas were evidently developed by Domenichino, and were part of the basis of the 'new naturalistic landscape' for which the Bolognese painters became renowned.

Lent by Denis Mahon, Esq., C.B.E.

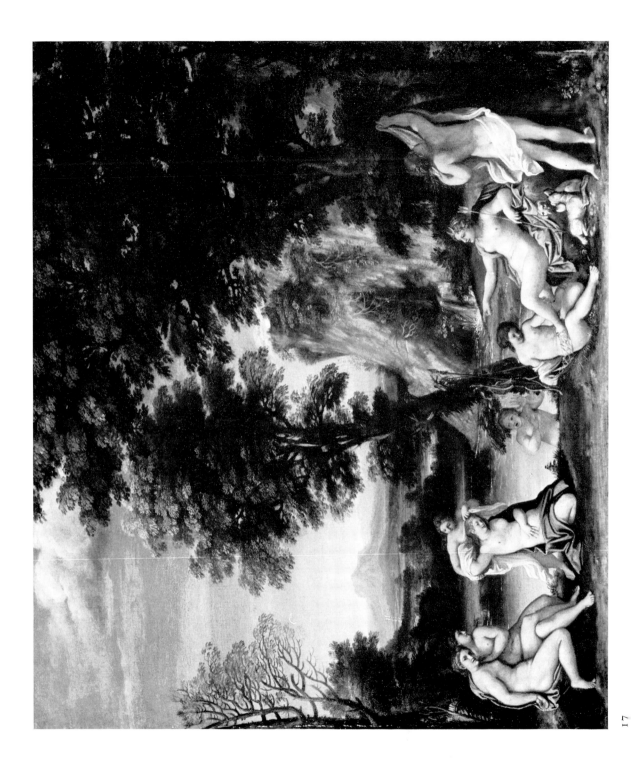

Annibale Carracci 1560–1609

17 *Diana and Callisto*

Canvas, 34¼ by 40¾ inches, 87 by 103·5 cms

See frontispiece for detail

Collections: Acquired in Italy by the painter Jacques Stella, who returned from Rome to Paris in 1634; Abbé de la Noue († before 1657); bought from him by M. le Président Antoine Tambonneau († 1707); bought by the Régent for the Palais Royal collection; the Duc d'Orléans, before 1707; sold in London, 1798/99, and bought by the Duke of Bridgewater; by descent to the present owner.

Exhibited: Cardiff, National Museum of Wales, *Ideal and Classical Landscape*, 1960, No.20.

Literature: G. P. Bellori, *Vite...*, 1672, p.86; A. Félibien, *Entretiens...*, 1688, II, p.86; Dubois de Saint Gelais, *Description des Tableaux du Palais Royal*, 1727, p.37; *Galerie du Palais Royal*, 1786, engraved by de Lamercy; W. Y. Ottley and P. Tomkins, *The Stafford Gallery*, 1818, No. 45; J. D. Passavant, *Tour of a German Artist in England...*, 1836, Vol.II, p.185; G. F. Waagen, *Treasures of Art...*, 1854, II, pp.35, 488; E. Bonnaffé, *Dictionnaire des amateurs français au XVIIième siècle*, 1884, pp.158, 297/98, 300; R. Martin, *The Farnese Gallery*, 1965, pp.56, 108, 214, Fig.276; D. Posner, *Annibale Carracci*, 1971, Vol.I, p.118–19, Vol.II, p.50, No.112, & p.68; *Nuove Acquisizioni per i Musei dello Stato, 1966–1971*, 1971, Bologna, pp.48–50.

Engraved: also by B. Picart, 1707 (when it was already in the Orléans Collection).

This, one of the most important landscapes painted by Annibale in Rome, must date from the last years of the sixteenth century, while he was working on the Farnese Gallery. Its *pendant*, the *Toilet of Venus*, which has been separated from it since the 1798/99 Orléans sale in London, has recently been rediscovered and acquired by the Pinacoteca Nazionale in Bologna.

So far as landscape is concerned, the composition gives organized form to the more loosely-knit paintings and drawings of the Bolognese period. The balance of scale between the figures in the foreground and the background was evidently carefully worked out, and this is an element which subsequent Bolognese landscapes have in common. From the early years of the new century, there existed schemes of decoration incorporating landscapes of this new type, painted by the Carracci school. Among them, we know that the garden pavilion at the Palazzo Farnese contained compartmented ceilings with landscapes, begun in about 1602/03, which included a school version of the *Toilet of Venus*, as well as a version of the well-known *River Landscape* now in Berlin (as can be ascertained from the published Farnese inventories and the unpublished 1653 inventory, MS 86, Archivio di Stato, Parma).

It has been pointed out by Martin that the group on the left, which might have been inspired by a classical gem, appears first in Agostino's *Reciprocal Love* in Vienna, in an engraving by the same artist dated 1599 (*Omnia vincit Amor*; Bartsch, XVIII, No.116; drawing in the Städelsches Kunstinstitut, Frankfurt/M), and on the left in

Annibale's painting of *Thetis carried to the Bridal Chamber of Peleus* in the Farnese Gallery. A painted version of the engraving is at Apsley House; Posner lists a copy of the *Diana and Callisto* in the Koepfli Collection, Los Angeles.

It was doubtless the importance of Annibale's example for the young Domenichino that led Waagen to suggest that the painting exhibited here might be by him. Conversely, the similarity of many details to those of the *Landscape with Sylvia and the Satyr* (a picture with a long history in English collections as Domenichino, now in the Pinacoteca Nazionale in Bologna) suggests that too may be by Annibale. This theory is supported by the existence among the Annibale drawings in the Louvre of a study closely related to the group of Sylvia being seized by the Satyr (Cabinet des Dessins, Inv. No. 7456). The inspiration that Domenichino drew from his teacher will be amply apparent in this exhibition; the extent to which this must have depended on new principles of landscape composition (rather than the imitation of specific paintings) is illustrated by the relatively few landscapes in existence from Annibale's own hand.

Lent by the Duke of Sutherland.

Lodovico Carracci 1555–1619

18 *The Marriage of the Virgin*

Copper, 15⅞ by 12¼ inches, 40·3 by 31·1 cms

Collection: acquired by the present owner in 1955.

Exhibited: Bologna, *I Carracci*, 1956, No. 52 (as by Annibale); Royal Academy, *Italian Art and Britain*, 1960, No. 395.

Literature: F. Arcangeli, Paragone, 79, 1956, p. 23ff. (as Annibale); M. Jaffé, Burlington Magazine, 98, 1956, p. 394; H. Voss, Kunstchronik, IX, 1956, p. 320; M. V. Brugnoli, Bollettino d'Arte, 1956, p. 357f.; Denis Mahon, Gazette des Beaux-Arts, April, 1957, p. 198.

Although this painting was exhibited at the Carracci exhibition in Bologna as by Annibale, critical opinion is now almost unanimous in regarding it as a work of Ludovicos. It would date from around 1589, and it has been suggested that it may be a picture recorded by Malvasia at the Palazzo Tanari in Bologna (*Felsina Pittrice*, 1678, 1, p. 495).

Lent anonymously.

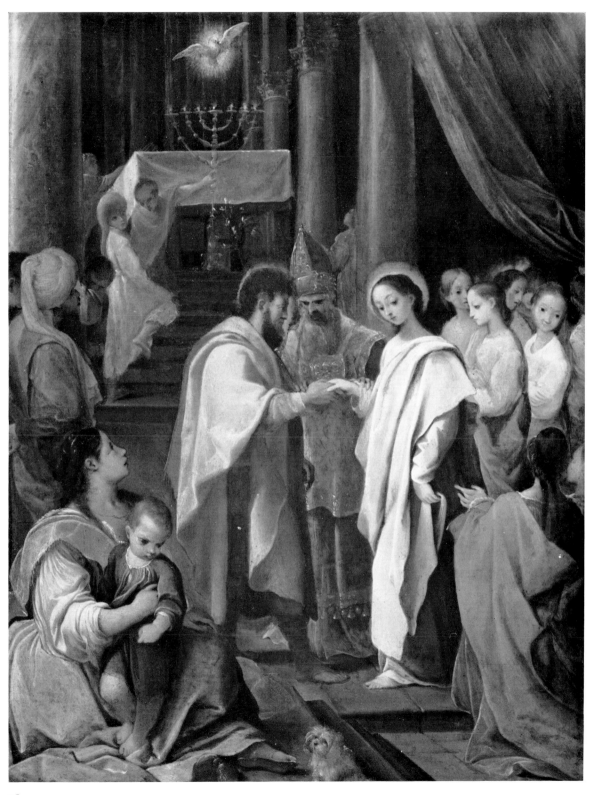

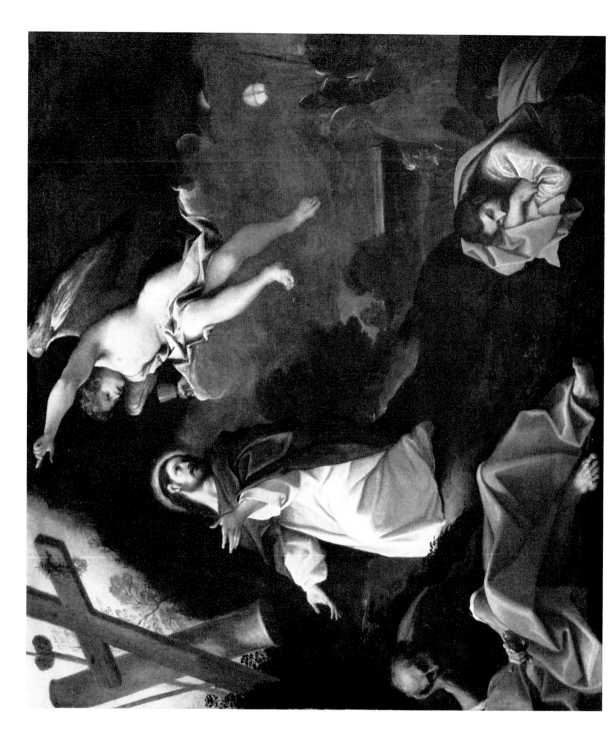

Lodovico Carracci 1555–1619

19 *The Agony in the Garden*

Canvas, 39½ by 45 inches, 100·3 by 114·3 cms

Collection: Robert Napier, West Shandon, until 1877; Colnaghi.

Exhibited: Colnaghi, *Paintings by Old Masters*, 1960, No.1; Detroit, Institute of Arts, *Art in Italy 1600–1700*, 1965, No.66.

Literature: Robinson, *The Collection of Robert Napier*, 1865, p.17; B. Nicolson, *Great Private Collections* (ed. D. Cooper), 1963, p.120.

Here Lodovico evidently has the example of Correggio in mind. Another related *Agony in the Garden* by Lodovico, with Christ swooning at the sight of the chalice, is the smaller painting in the Prado (No.74; A. E. Perez-Sanchez, Pintura italiana del siglo XVII en España, 1965, p.112, Pl.11), which is first mentioned by Bellori in Carlo Maratta's collection (*Vite inedite* . . . , ed. M. Piacentini, 1942, p.123).

The exhibited painting dates from the late 1580s, a time when there was perhaps the greatest stylistic community between the work of Ludovico, Agostino and Annibale. It has affinities with the *Vision of St. Anthony* in the Rijksmuseum in Amsterdam, which dates from about 1586. The romantic play of light in works of this kind is of obvious importance for the development of Lanfranco, Badalocchio, and even the young Reni.

Lent by Denis Mahon, Esq., C.B.E.

Lodovico Carracci 1555–1619

20 *A Vision of St. Francis*

Copper, 14½ by 11¼ inches, 37.5 by 28.5 cms

This unpublished *Vision of St. Francis* is not distant in date from the *Agony in the Garden* also exhibited here. Its diagonal composition anticipates on an intimate scale Lanfranco's powerful altarpieces of around 1620, such as the *Ecstasy of St. Margaret of Cortona*, in the Pitti Gallery. The Child is close in type to that of Lodovico's large altarpiece of the *Madonna degli Scalzi* (Bologna, Pinacoteca) perhaps painted about 1593.

Lent anonymously.

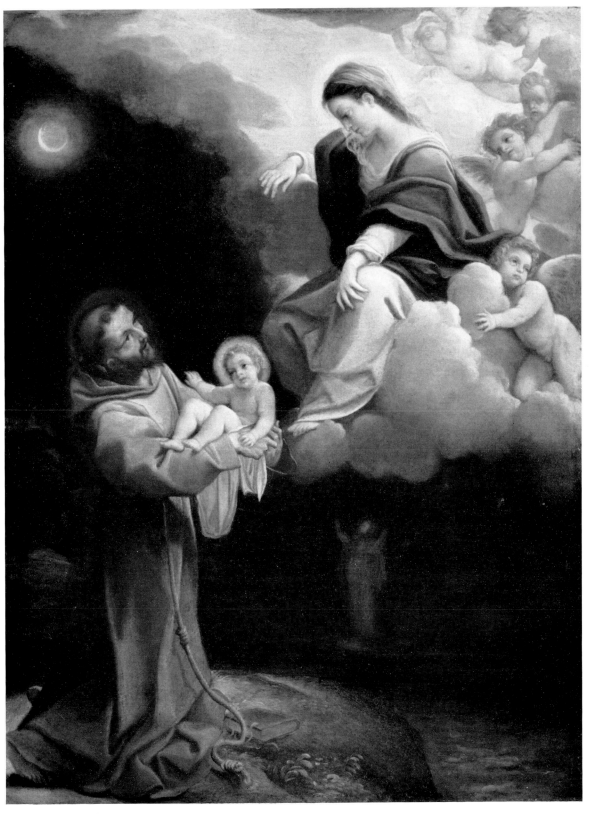

Domenico Zampieri, called Domenichino 1581–1641

21 *Abraham and Isaac*

Copper, 12½ by 17½ inches, 31·7 by 44·4 cms

Collections: Probably painted for Cardinal Pietro Aldobrandini in 1602 (see below); Donna Olimpia Aldobrandini; Ducs d'Orléans (before 1727); sold with the Orléans collection in London, 1798/99, and bought by Ward; Anon. Sale, Christie's, June 20, 1807, No.78, bought Roberts, £210; Brothon, Sale, Christie's, Jan 26, 1811, No. 42, bought in at £210; Litt, Sale, Christie's, July 14, 1828, No.100, £152 5s; William Wilkins, R.A., his Sale, Christie's, April 7, 1838, No.22, £204 15s, bought by the Marquess of Lansdowne.

Exhibited: British Institution, *Old Masters*, 1832, No.164; Burlington Fine Arts Club, 1925, No.26; Agnew's, *Loan Exhibition of the Lansdowne Collection*, 1954/55, No.19.

Literature: Dubois de Saint Gelais, *Description des Tableaux du Palais Royal*, 1727, p.121; *Galerie du Palais Royal*, 1786, 1 (engraved); Anna Jameson, *Companion . . . Private Galleries of Art* 1844, p.302, No.14; G. F. Waagen, *Treasures of Art . . .*, 1854, Vol.III, p.162; G. E. Ambrose, *Catalogue . . . Lansdowne Collection*, 1897, p.27, No.164; E. Borea, *Varie sul Domenichino*, Paragone, 191/11, 1966, January, Fig.62.

This is one of the earliest works painted by Domenichino in Rome, where the artist arrived from Bologna towards the middle of 1602. Along with the National Gallery *St. Jerome* (National Gallery No.85) a description of such a painting is listed in an inventory of Cardinal Pietro Aldobrandini's collection completed in January 1603 (published by C. d'Onofrio, *Inventario dei dipinti del Cardinal Pietro Aldobrandini compilato da G. B. Agucchi nel 1603*, Palatino, 1964, Nos.9–12). This was drawn up by Domenichino's most important patron G. B. Agucchi (see No.24) who was at the time major-domo to Cardinal Aldobrandini, and enriched the latter's collection with a number of Bolognese works. An *Abraham and Isaac* is listed under No.331 of the inventory 'Un quadretto con un paese con l'istoria d'Abraam per sagrificare Isaac di mano di Domenico Zampieri con cornice nera'. A later Aldobrandini inventory (also published by d'Onofrio) provides a measurement – it was 1¼ *palmi* high, which corresponds with the Lansdowne painting. As in the picture itself, the inventory description indicates not so much the sacrifice of Abraham as Abraham going with Isaac for the sacrifice. The Aldobrandini collection was of course one of the principal sources of Seicento Bolognese paintings acquired by collectors at the end of the eighteenth century.

As Waagen wrote 'The poetic composition, fine transparent colour, and singularly careful execution render this a perfect jewel'. It is of considerable interest since it shows Domenichino as an accomplished landscapist already on his arrival in Rome; that also reflects on the tradition established in Bologna, where Annibale had been absent since 1595.

Lent by the Earl of Shelburne.

Domenico Zampieri, called Domenichino 1581–1641

22 *St. Jerome in a Landscape*

17 by 23 inches, 43 by 58·4 cms.

Collections: Ducs d'Orléans (by 1727); sold in London with the Orléans collection in 1798/99, and bought by (£250) John Maitland, his Sale, Christie's, July 30, 1831, bought by Woodburn, £157 10s; Archibald M'Lellan; acquired with the M'Lellan Collection by the Gallery in 1856.

Literature: Dubois de Saint Gelais, *Description des Tableaux du Palais Royal*, 1727, p.124; *Galerie du Palais Royal*, 1786 (engraved); W. Buchanan, *Memoirs*, 1824, I, p.101; M. Passavant, *Tour of a German Artist* ..., 1836, Vol.II, p.188; J. Paton, *Catalogue ... Glasgow Art Gallery*, 1908, p.58, No.276; 1935 Catalogue, p.85, No.139; E. Borea, *Varie sul Domenichino*, Paragone, 191/11, 1966, Fig.61.

Engraved: apart from the Palais-Royal engraving, there is also one by Bowyer (1819).

This St. Jerome is an early example of Domenichino's landscape style, to be placed in date between the National Gallery *St. Jerome* (85: datable to 1602) and the Mahon collection *St. Jerome with an Angel* which was painted while the artist was living with Monsignor Agucchi (from at least 1604 onwards). All three paintings owe something to Agostino Carracci's 1602 print of the saint, which he left unfinished at the time of his death. This landscape also reflects Agostino's landscape style, as well as that of Annibale.

The perspective arrangement is reminiscent of Edward Norgate's account of Paul Brill's advice to him probably imparted in about 1625 in Rome and reflecting ideas culled from the new Italian landscape.

'Yet one generall rule I had from my old friend, Paulo Brill, which hee said will make a Lanscape *caminare*, that is move or walk away, and that is by placing Darke against Light, and light against Darke'. (*Miniatura*, ed. 1919, p.48).

Both Buchanan and Passavant refer to the *Landscape with St. Jerome* in the Orléans collection having been sold to the Duke of Bridgewater (for £500), but the reference that this picture came from the Hautefeuille collection confirms that it was the *Landscape with a Fortified Building*, No.29 in this exhibition. The same authors list 'A Marine Landscape' as having been bought by John Maitland for £250, and from its later appearance in his sale, this is evidently the picture.

Lent by the Glasgow Art Gallery.

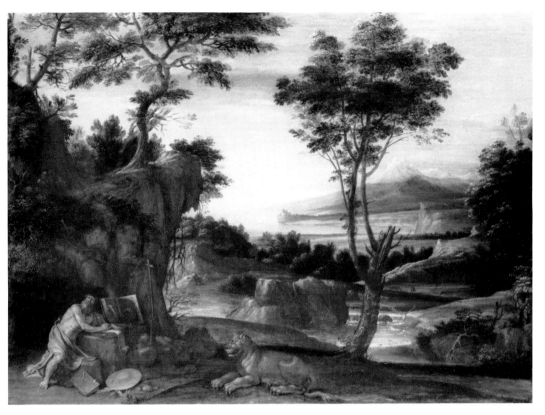

22

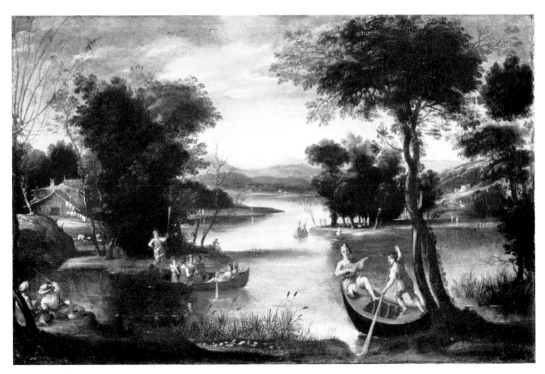

23

Domenico Zampieri, called Domenichino 1581–1641

23 *Landscape with a Boating Party*

Canvas, 13¾ by 21½ inches, 35 by 54·5 cms

Collections: acquired by the present owner in 1957.

Exhibited: Royal Academy, *Italian Art and Britain*, 1960, No.394; Newcastle-on-Tyne, The Hatton Gallery, *The Carracci, Drawings and Pictures*, 1961, No.201, Pl.IV; Bologna, *L'Ideale Classico e la Pittura di Paesaggio*, 1962, No.13; Utrecht, Centraal Museum, *Italieniserende Landschapschilders*, 1965, No.174; Frankfurt am Main, Städelches Kunstinstitut, *Adam Elsheimer*, 1966/67, No.67.

Literature: B. Nicolson, The Burlington Magazine, 102, 1960, p.73, Fig.40; D. Sutton, Arte Figurativa, VIII, No.2, 1960, p.19; D. Sutton, Country Life Annual, 1961, p.16, Fig.3; D. Sutton, *Goya*, 1961, p.251,repr. p.252; E. Borea, *Domenichino*, 1965, p.195; D. Posner, *Annibale Carracci*, 1971, Vol.II, p.80, No.193(R); M. Levey, National Gallery Catalogue, *Seventeenth & Eighteenth Century Italian Schools*, 1971, pp.77/78.

This landscape was exhibited initially as a work by Annibale Carracci of around 1590, an attribution supported by the existence of a pen and ink drawing formerly in the Ellesmere Collection (Bologna, *I Carracci, Disegni*, No.240) which is linked with the boating party. Now it has gained credence as a Domenichino, and indeed it is stylistically incompatible with Annibale's work. It is somewhat confusing, in the study of the Carracci and their school, to find drawings that seem to be associated with pictures, and which in fact may only have been used as starting points. It was certainly the practice in the Carracci studio from the start to keep drawings, and work from them; this practice must indeed have increased considerably during Annibale's illness (from 1604/05 onwards).

Like the painting from Glasgow, this landscape dates from relatively early in Domenichino's career. It also reveals reminiscences of Agostino – particularly in the Campagnola-like rustic farm at the left. Both have elaborate planes of recession placed diagonally, and this picture seems to be the painted equivalent of such drawings by Agostino as the *Landscape with a Rocky Height* (formerly in the Ellesmere collection, P. A. Tomory, *The Ellesmere Collection* . . ., 1954, No.39, Pl.XL).

From the Abraham and Isaac (No.21) to these two pictures, Domenichino would seem to be still expressing ideas that derive partly from his training in Bologna. With landscapes like the *Guado* in the Doria Pamphili Gallery (Bologna, 1962, No.21) he moves wholeheartedly into Annibale's style, as illustrated by the latter's *St. John the Baptist Preaching*, in Grenoble.

Lent by Denis Mahon, Esq., C.B.E.

Domenico Zampieri, called Domenichino 1581–1641

24 *Monsignor Agucchi*

Canvas, 23¾ by 18¼, 60·3 by 46·3 cms

Collections: Agucchi family; Conte Cavaliere Alessandro Agucchi Legnani (until after 1850); Sir Edgar Sebright; his sale, Christie's, 2 July, 1937, No.37, bought by Sir Kenneth Clark; Arcade Gallery, 1944; F. D. Lycett Green; by whom presented to the York City Art Gallery, through the National Art Collections Fund, in 1955.

Exhibited: Royal Academy, *Old Masters*, 1908, No.3; York, City Art Gallery, *Lycett Green Collection*, 1955, No.66; Bologna, *L'Ideale classico e la pittura di Paesaggio*, 1962, No.28; Royal Academy, *Primitives to Picasso*, 1962, No.112.

Literature: G. F. Tomasini, . . . *Elogia virorum literis et sapientia Illustrium*, Padua, 1644 (engraved); Conte Valerio Zani, *Memorie, Imprese e Ritratti de' Signori Accademici Gelati di Bologna*, 1672, p.84 (engraving by Otteren); C. C. Malvasia, *Felsina Pittrice*, 1678, 1, p.107/8; ed. 1841, 1, p.89, n.; Marcello Oretti, MS, *circa* 1780, Bologna, Biblioteca Communale, MS B. 128, f.5,6 (cited as being in Casa Fioravanti, Bologna); G. Lenzi, *Vita di Monsignor Giambattista Agucchi*, 1850 (engraved as frontispiece); J. Pope-Hennessy, *Two Portraits by Domenichino*, The Burlington Magazine, Vol.82, 1946, p.186; York Art Gallery, *Preview*, 30 April 1955, p.312; National Art Collections Fund, *Report*, 1955, p.39; E. Borea, *Domenichino*, 1965, p.178, No.69; York City Art Gallery Catalogue, 1, 1971, p.16, No.787.

The painting was originally larger, but was reduced to its present proportions by the time of the 1850 engraving.

Monsignor Giovanni Battista Agucchi (1570–1632) is now recognized as having played an important part both in patronizing Bolognese painters and in promoting discussion of art theory at the beginning of the seventeenth century (see especially Denis Mahon, *Studies in Seicento Art and Theory*, 1947, p.111ff.). The seventeenth century historians refer to his *Treatise on Painting* as having been composed with the help first of Annibale, and then of Domenichino, who was living in his house in 1604 (for an earlier painting commissioned through Agucchi, see No.21). His ideas on painting were obviously influential even before the completion of that document, which has only survived in part. The concept of 'il Bello', which is the core of Bellori's *Idea* dates in Agucchi's letters from as early as 1602/03. Bellori is known to have possessed a copy of the Treatise; he was in any case tutored by Agucchi's friend Francesco Angeloni. Agucchi's ideas are thus at the heart of the classical tradition in painting.

It is generally accepted that this portrait was painted during the papacy of Gregory xv (1621–23) when Agucchi was First Minister and Segretario de' Brevi;

it was a period when Domenichino was also in favour, securing the position of Papal Architect. The portrait is particularly appropriate to Agucchi's position as Segretario de' Brevi; apart from this official capacity, he was an assiduous correspondent. After 1623, he left the Roman artistic scene to become Papal Nunzio in Venice.

Lent by the City Art Gallery, York.

Domenico Zampieri, called Domenichino 1581–1641

25 *The Conversion of St. Paul*

Canvas, 23¾ by 34½ inches, 60·3 by 87·6 cms

This is a *modello* for the altarpiece painted by Domenichino for Bernardo Inghirami, Bishop of Volterra, to be placed in the Cappella di San Paolo (the Cappella Inghirami) in the Duomo, Volterra. The documents published by Giglioli (*La Cappella Inghirami nella Cattedrale di Volterra*, in Rivista d'Arte, XII, 1930, pp.429–54) show that the altarpiece was completed at the beginning of 1623. The painting is executed in very much the same style as the *Martyrdom of St. Agnes*, the great altarpiece that Domenichino painted at this period for the church of S. Agnese in Bologna, now in the Pinacoteca there.

It is ironic that as Guercino was beginning to feel the impact of Bolognese classicism, Domenichino should at the same moment feel a reciprocal influence. Whatever the course of Guercino's own later style, works like his great *Burial of Saint Petronilla*, painted in 1622/23 for St. Peter's, were major artistic events on the Roman scene. The Guercinesque character of this composition is also perhaps more understandable because the alterpiece was not destined for a Roman church.

A group of studies for the composition are at Windsor Castle (J. Pope-Hennessy, *The Drawings of Domenichino at Windsor Castle*, 1948, p.47).

Lent anonymously.

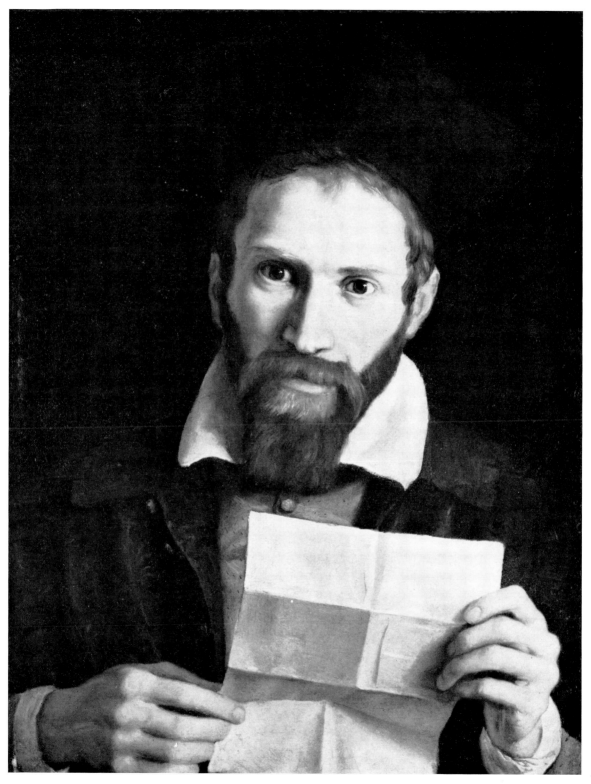

Domenico Zampieri, called Domenichino 1581–1641

26 *The Madonna della Rosa*

Canvas, 43½ by 33 inches, 110·5 by 83·8 cms (sight size 37¼ by 28⅜)

Inscribed at bottom:

LAETUS CHRISTE ROSAS HOMINI LARGIRIS AMOENAS
INGRATUS SPINAS HEU TIBI REDDIT HOMO

Collections: Santa Maria della Vittoria, Rome (before 1672); purchased by the 3rd Earl of Burlington, 1714, and by family descent.

Exhibited: Royal Academy, *Holbein and other Masters*, 1950/51, No.330

Literature: R. Wittkower, *Domenichino's Madonna della Rosa*, The Burlington Magazine, Vol.90, 1948, p.220ff (which see also for earlier references); E. Borea, *Domenichino*, 1965, p.192.

The picture is widely referred to in the seventeenth century sources and early guidebooks to Rome. Hanging in the sacristy of Santa Maria della Vittoria, it was an attractive prize for the English collector on the Grand Tour. Evidently determined to secure a genuine work by the master, the Earl of Burlington persuaded the church authorities to part with the picture for 1500 crowns, more than he expended on any other picture during his entire journey. In Walpole's day, Burlington was credited with having furnished the church with a set of marble columns in exchange for the painting. Enthusiasm for Domenichino rivalled that for Raphael himself, and the work of the seventeenth century Bolognese classicists was certainly compatible with the interiors in which they were hung in England. The *Madonna della Rosa* hung in the Red Velvet Room at Chiswick until the nineteenth century, when the entire Burlington collection was removed to Chatsworth.

As R. Wittkower pointed out, the representation is not simply that of a Madonna and Child, but the Rose is an allusion to the Crown of Thorns, as is made clear by the inscription at the base. This is a subject that enjoyed some popularity among Bolognese painters, and seems to have originated with Parmigianino's *Madonna della Rosa* now in Dresden.

From the Devonshire Collection, Chatsworth: Lent by the Trustees of the Chatsworth Settlement.

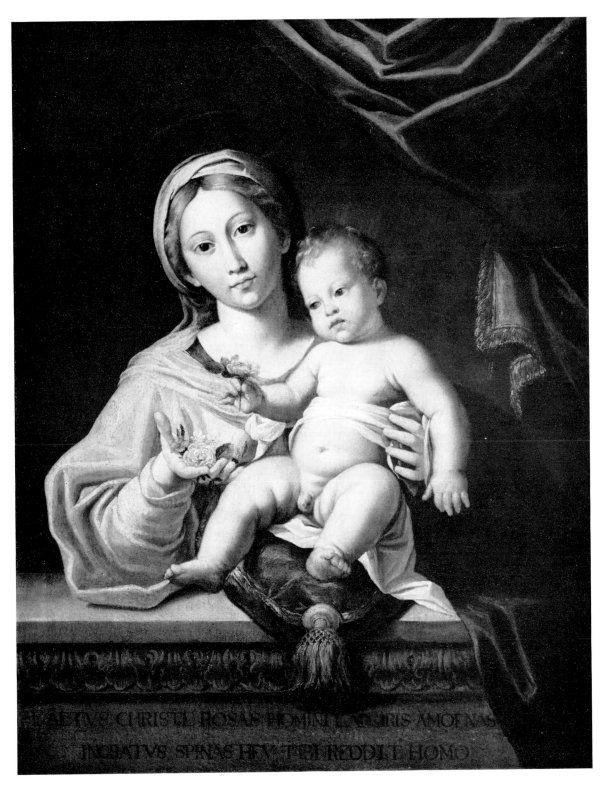

BEATVS CHRISTI ROSAS HOMINI LARGIRIS AMOENAS
INGRATVS SPINAS HEV TEI REDDIT HOMO

26

Domenico Zampieri, called Domenichino 1581–1641

27 *The Expulsion of Adam and Eve*

Copper, 27 by 21½ inches, 68·5 by 54·5 cms

Collections: Pierre Crozat (1661–1740); bought from him by the 2nd Duke of Devonshire, 1722.

Exhibited: Royal Academy, *Holbein and other Masters*, 1950/51, No.329.

Literature: Pierre Crozat, MS letter, 1st series, 170·2. *Recueil d'Estampes d'après les plus beaux tableaux . . .*, 1729, No.140 (engraved by Tardieu), 1742, II, 41; S. Dodsley *London and its Environs*, 1761, II, 226; E. Borea, *Domenichino*, 1965, p.180.

This was acquired from the famous French collector Crozat by the Duke of Devonshire in 1722 for 1800 livres. Crozat's letter (see above) at Chatsworth describes the painting as in his opinion as being among the very finest of Domenichino's works, and if he had not known how much the Duke wanted it he would not have parted with it for three times the money. He compared it with a duplicate in the possession of the French King.

Domenichino in fact painted the subject a number of times, and versions are mentioned both by Bellori and by Félibien. Probably during the papacy of Gregory XV (1621–23) he painted a series of four canvases including a *Fall* and an *Expulsion*, for the Principe Ludovisi di Zagarolo. Perhaps from this series was the *Adam and Eve* which belonged in the seventeenth century to Le Nôtre, and then to the French Royal collections. A version on copper of the *Expulsion* was, however, in France in Félibien's day (*Entretiens . . .* etc., 1688 ed., 2, 267), and this may have been the version acquired by Crozat. Another version on copper is the one in the Museum at Grenoble reproduced by E. Borea, who also lists other references.

From the Devonshire Collection, Chatsworth: Lent by the Trustees of the Chatsworth Settlement.

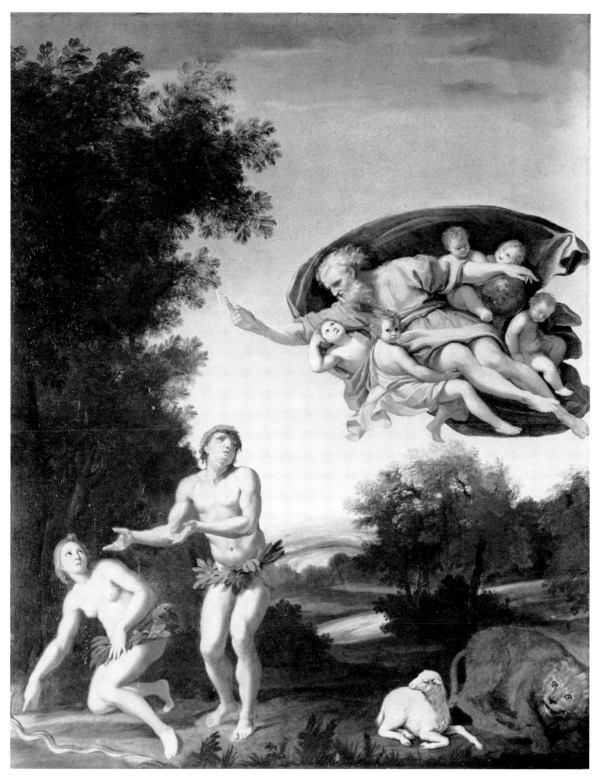

Domenico Zampieri, called Domenichino 1581–1641

28 *St. John the Evangelist*

Canvas, 102 by 78½ inches, 259 by 199 cms

Collections: Painted for Marchese Vincenzo Giustiniani (1564–1637); by descent to Principe Giustiniani, Rome, until about 1806; imported by Delahante and sold to Harris; R. Hart Davies; Philip John Miles, Leigh Court, by about 1813; Leigh Court Sale, June 28, 1884 (22), bought in; bought later privately by A. L. Christie.

Exhibited: Royal Academy, *Holbein and other Masters*, 1950/51, No.328; Rome, *Mostra del Seicento Europeo*, 1956, No.90, Pl.42.

Literature: G. P. Bellori, *Vite*, 1672, p.252; G. Vasi, *Itinerario di Roma*, 1804, p.346; J. Young, *Leigh Court Gallery*, 1822, p.5 (engraved); W. Buchanan, Memoirs, II, 1824, pp.154 and 193, No.16; G. F. Waagen, *Treasures of Art . . .*, 1854, Vol.III, p.182; J. Pope-Hennessy, *Domenichino Drawings at Windsor Castle*, 1948, p.104, under Nos.1246/47; J. J. Winckelmann, *Briefe*, IV, Berlin, 1957, pp.39, 435; E. Borea, *Domenichino*, 1965, p.188, No.94; L. Salerno, *The Picture Gallery of Vincenzo Giustiniani*, The Burlington Magazine, Vol.102, 1960, p.102.

This celebrated picture, the subject of repeated offers to the Principe Giustiniani at the turn of the eighteenth and nineteenth centuries, before he sent his whole collection for sale to Paris, shows Domenichino's powers as a painter on a larger scale. It belonged originally to a series of Evangelists painted by Guido Reni (*St. Luke*), Nicolo Regnier (*St. Matthew*), Francesco Albani (*St. Mark*) and Domenichino, for the Marchese Vincenzo Giustiniani. When Bellori saw it in the Giustiniani collection he assumed that it and the two other Evangelists by Reni and Albani had been painted to accompany Caravaggio's first (rejected) version of *St. Matthew* for San Luigi dei Francesi; but the Giustiniani inventory makes it clear that the *St. Matthew* for this series was in fact provided by Regnier (Renieri).

The composition is certainly linked with that of the St. Luke that Domenichino painted in one of the pendentives of S. Andrea della Valle, which were completed for the Jubilee of Pope Urban VIII in 1625. Two drawings related to the present composition are at Windsor (J. Pope-Hennessy, *loc. cit.*). The pendentives themselves and the rest of the paintings in the apse at Sant' Andrea della Valle, were the artist's most successful decorative scheme. Stylistically in competition with Lanfranco, who contrived to secure the commission for the decoration of the cupola, the pendentives show Domenichino's ability to cope with the problems of architectural space. In this *St. John*, the large forms are tempered by a classical restraint that was a conscious answer to Lanfranco's illusionism.

Lent by the Christie Estate Trust.

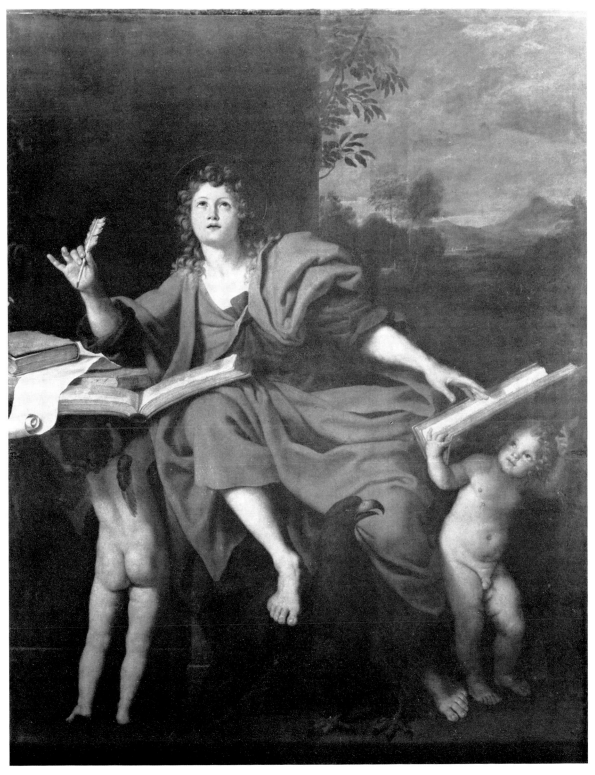

Domenico Zampieri, called Domenichino 1581–1641

29 *Landscape with a Fortified Building*

Canvas, 44 by 76 inches, 111·8 by 193 cms

Collections: Commandant d'Hautefeuille, Paris (Etienne Texier d'Hautefeuille, † 1703; cf. E. Bonnaffé, *Dictionnaire des Amateurs français au XVIIIième siècle*, 1884, p.136); Ducs d'Orléans; sold in England with the Orléans Collection in 1798/99; purchased by the Duke of Bridgewater, and by descent to the Earl of Ellesmere; acquired by the present owner, 1946.

Exhibited: Wildenstein, London, *Artists in Seventeenth Century Rome*, 1955, No.35, Birmingham, City Art Gallery, *Exhibition of Italian Art*, 1955, No.39; Zürich, Kunsthaus, *Unbekannte Schönheit*, 1956, No.280; Berlin, Dahlem Museum, 1956; Rome, *Mostra del Seicento Europeo*, 1956/57, No.87; Royal Academy, *Italian Art and Britain*, 1960, No.398; Bologna, *L'Ideale classico e la pittura di Paesaggio*, 1962, No.35; Detroit, Institute of Arts, *Art in Italy 1600–1700*, 1965, No.78.

Literature: Dubois de Saint Gelais, *Description des Tableaux du Palais Royal*, 1727, pp.125/26 (with Hautefeuille provenance); A. N. Dézallier d'Argenville, *Voyage Pittoresque de Paris*, 2nd ed., 1752, p.70; *Galerie du Palais Royal*, 1786, No.VIII of Domenichino, engraved by Michel; C. P. Landon, *Vies des Peintres*, Pl. CL of *Domenichino* (engraved by Devilliers); W. Y. Ottley and P. Tomkins, *The Stafford Gallery*, 1818, Class II, No. 54 (engraved by C. Heath, 1814); Anna Jameson, *Private Galleries of Art*, 1844, p.105 (No.34); G. F. Waagen, *Treasures of Art . . .* , 1854, II, pp. 35ff & 490; J. Pope-Hennessy, *The Drawings of Domenichino at Windsor Castle*, 1948, pp.27, 44, Fig.3; G. Briganti, *The Mahon Collection . . .* , The Connoisseur, 132, 1953, pp.6–8, 16, Fig.VII; R. Longhi, Paragone, 67, July 1955, p.63; D. Sutton, Paragone, 71, Nov., 1955, p.33, Fig.16; H. Voss, Kunstchronik, X, 1957, p.88; T. Mullaly, Apollo, Aug., 1957, p.34; F. M. Godfrey, *Later Italian Painting, 1500–1800*, 1958, p.347, Fig.260; M. Roethlisberger, *Claude Lorraine*, 1961, p.306ff.; G. C. Cavalli, *L'Ideale Classico del Seicento . . .* , 1962, pp.122–24; M. Jaffé, Burlington Magazine, 104, 1962, p.417; B. Nicolson, *Great Private Collections* (ed. D. Cooper), 1963, p.120; E. Borea, *Domenichino*, 1965, p.195; R. E. Spear, The Art Bulletin, 1967, 49, p.367.

As a successful painter of altarpieces and history paintings, Domenichino seems largely to have given up the medium of landscape painting around the middle of his career. We know he *designed* the frescos from the Stanza d'Apollo at Frascati (executed 1616/18, now in the National Gallery in London) – but the paintings themselves were left in the main to assistants. He again used the landscapist G. B. Viola, who specialized in this sort of work, in 1621/23, to paint the background of the Pallavicini *Garden of Eden*, and possibly other more important paintings.

But there were exceptions to this studio practice, and the painting exhibited here is undoubtedly (*pace* Borea, who expressed the belief that it is a copy or studio piece) one of the landscapes Domenichino painted later in his career. At what moment it is difficult to determine on stylistic grounds, since there are few points of comparison. The handling is much broader, and contrasts with the concentrated

clarity of earlier works. Neither is there a satisfactory comparison in terms of figure painting, but it is clear that this is a mature work in all senses, and it could well date from the 1630s, as originally suggested by Sir John Pope-Hennessy on the basis of the preliminary drawings now at Windsor. Certainly the example of Domenichino was taken up in the 1630s, and in paintings that reflected the breadth and scale that emanate from this rather than the earlier jewel-like works.

The painting is a free variation of the best-known of the Aldobrandini lunettes, now in the Galleria Doria-Pamphili in Rome, a series that Domenichino may well have participated in himself during the period of their execution, 1604–13. Instead of a *Flight into Egypt*, however, the figures in this painting impose a genre character on the whole scene, poetic in a more intimate manner. (There may be a reference to the original subject in the group of figures in the middle distance that seem to represent the *Flight*.) To date, this is the only exercise by Domenichino in this manner; but a related painting has yet to receive the critical attention that is its due. This is the *Landscape with Boats* in the Prado, Madrid (No.81; first published by E. Borea, *Aspetti del Domenichino Paesista*, Paragone, 123, 1960, 9, Fig.9b, but tacitly rejected by omission in her 1965 book; rejected by Spear, *loc. cit.*) which for various reasons must date from the same moment as the *Landscape with a Fortified Building*.

The Prado painting (No.81; 112 by 149 cms; illustrated also in A. E. Perez-Sanchez, *Pintura italiana del siglo XVII en España*, 1965, Pl.77; its history goes back to the Maratta collection at La Granja) has the same broad handling as the work exhibited here, and repeats features such as the hut on the left and the boat on the right, whose profile reappears almost exactly. It has also escaped attention that a drawing at Windsor (J. Pope-Hennessy, *op. cit.*, p.118, No.1696, Fig.66; red chalk on white paper, 25·1 by 38·8 cms) is a preparatory composition study for the Prado painting, and is also related to Mr. Mahon's picture. Although the hut that appears in the exhibited painting is missing, the group on the left of the drawing of the mother and children are clearly related, both to the painting and to the drawings known to be associated with the picture. The chalk studies like these at Windsor and elsewhere seem to be generally late in date; it may be that late in his career Domenichino was called on to provide landscapes of the genre for which he had become famous. The absence of a history subject would be explained by this interest in Domenichino's landscape reputation, which certainly became important in the 1630s.

Lent by Denis Mahon, Esq., c.b.e.

Giovanni Francesco Barbieri, called Il Guercino 1591–1666

30 *The Madonna and Child with a Sparrow*

Canvas, 30⅞ by 22⅞ inches, 78·5 by 58 cms

Collections: Palazzo Borghese, Rome (listed in 1693 inventory; bears Borghese inventory No.105, lower left); purchased by William Young Ottley in Rome, 1799/1800, and brought to England; exhibited for sale by him at 118, Pall Mall, 1801 (p.6 No.24); Anon. Sale [Mr Morland's Executors], Phillips, 20 May, 1820, lot 63, bought by Samuel Rogers; his Sale, Christie's, 2 May, 1856, Lot 609, bought by Radclyffe for Miss (later Baroness) Burdett-Coutts; acquired by the present owner, 1946.

Exhibited: British Institution, *Old Masters*, 1821, No.74; British Institution, *Old Masters*, 1835, No.12; Manchester, *Art Treasures*, 1857, No.333 (368); Hazlitt Gallery, *Vasari to Tiepolo*, 1952, No.4; Rome, *Seicento Europeo*, 1956/57, No.122; Manchester, City Art Gallery, *European Old Masters*, 1957, No.143; Royal Academy, *Italian Art and Britain*, 1960, No.380; Bologna, *Il Guercino*, 1968, No.13 (which see for full history).

Literature: F. W. B. von Ramdohr, *Ueber Mahlerei . . . in Rome*, 1787, I, p.292; Anna Jameson, *Private Galleries of Art . . .* , 1844, p.396, and The Art-Union, IX, 1847, p.85; G. Briganti, *The Mahon Collection of Seicento Painting*, The Connoisseur, 1953, pp.9, 17, No.27; B. Nicolson, The Burlington Magazine, 104, 1962, pp.148/49; R. Roli, *I fregi centesi del Guercino*, 1968, p.40, Pl.22.

Engraved: by P. Bettelini (1763–1829) and Raffaello Persichini, both in an oval.

This is an early work, and was probably painted at Cento, Guercino's birthplace, around 1615/16. The figure of the Madonna is reminiscent of the same figure in the large altarpiece Lodovico Carracci painted for the church of the Cappuccini in Cento in 1591, and now in the Museo Civico there (repr. in *I Carracci*, Bologna, 1956, No.13).

Lent by Denis Mahon, Esq., C.B.E.

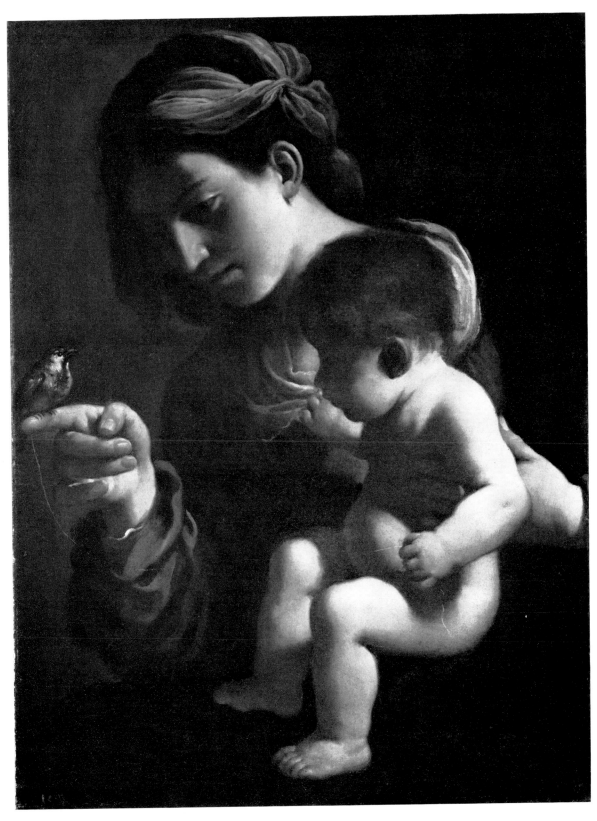

Giovanni Francesco Barbieri, called Il Guercino 1591–1666

31 *Saint Sebastian with two Angels*

Copper, 17 by 13 inches, 43·2 by 33 cms

Inscribed on the reverse: IO. FRANC. BARBERIUS A CENTO F/MDCXVII.

Collection: James Morrison, by 1857, and by descent.

Literature: G. F. Waagen, *Treasures of Art . . .*, Supplement, IV, 1857, p.308; D. Mahon, Catalogue, *Il Guercino*, 1968, pp.44/45.

Engraved: by G. B. Pasqualini, in reverse.

The obviously authentic inscription, dating the work securely to 1617, is a particularly interesting feature of this small copper; no works are recorded for this year in Malvasia's account of his career. A copy of the engraving by Pasqualini in Dresden bears the date 1623. Previously unexhibited, this important work is completely consistent in style with paintings like the *Susannah and the Elders* in the Prado, Madrid, and anticipates other small paintings on copper like the *Vision of St. Jerome* in the Louvre. As of the latter, other versions exist of the *St. Sebastian*; a copy is in Berlin (Gemäldegalerie der staatlichen Museen, Dahlem, No.1681). Another version is at Althorp in the collection of Earl Spencer.

Denis Mahon has suggested (*loc. cit.*) that the exhibited painting may have been in sales in London prior to entering the Morrison collection: that of John Humble, 11 April, 1812 (45), and that of William Hastings, 27–28 March, 1840 (87). The latter had been shown at the British Institution exhibition in 1835 (No. 113).

Lent by the Trustees of the Basildon Pictures Settlement.

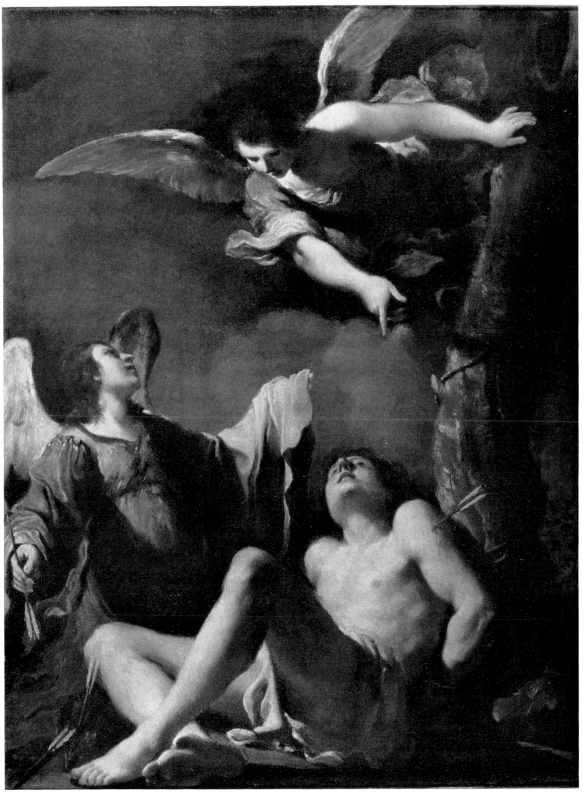

31

Giovanni Francesco Barbieri, called Il Guercino 1591–1666

32 *David and Goliath*

Fresco, 57 by 29½ inches, 132·5 by 65·5 cms

Collection: Hon. James A. Murnaghan, Dublin (by about 1925); Private collection, England.

Exhibited: Agnew's, *Old Masters*, *Recent Acquisitions*, 1968, No.2; Bologna, Palazzo dell'Archiginnasio, *Il Guercino*, 1968, No.24.

Literature: B. Nicolson, The Burlington Magazine, 110, 1968, p.228, Fig.90.

In his catalogue note to the 1968 Guercino exhibition in Bologna, Mr Denis Mahon dated this picture to around 1618, and linked with it three preparatory drawings by the artist. The fresco medium, and the wooden support to the plaster, are of particular interest in view of Guercino's commissions for fresco paintings at the Palazzo Tanari and the Oratorio di San Rocco in Bologna, in 1618. Mr Mahon surmised that this *David and Goliath* might have been executed as a sort of preliminary trial for his work in the medium of fresco, for which he was to receive several major commissions.

The picture is a true fresco painting, with the colours applied while the plaster was still wet; but the support of wooden slats shows that it was painted as a portative picture and not as part of a wall decoration as such, subsequently detached. Guercino used a variety of fresco techniques; even before his stay in Rome he probably painted *a secco* with tempera colours, giving a more opaque effect than *buon fresco*; he certainly employed the former technique in his work in the Casino Ludovisi and the Palazzo Costaguti. Guercino's decorations on the façade of Palazzo Tanari (which have not survived) may well, however, have been executed in the true *buon fresco*; this is probably also the case with the surviving painting in the Oratorio di San Rocco.

Two of the preliminary drawings for the picture were also shown at the 1968 Bologna exhibition (Nos.26, 27); the earliest, however, is the study in the Louvre (Inv. 6862) illustrated in S. Bottari, *Guercino, Disegni*, 1966, Pl.xi. Both the Royal Library, Windsor drawing and the *verso* of the Uffizi drawings show a composition with Goliath's head to the left; the *recto* of the Uffizi drawing is essentially that which Guercino used in the painting.

Lent by Thos. Agnew and Sons Ltd.

Giovanni Francesco Barbieri, called Il Guercino 1591–1666

33 *Saint John the Baptist in Prison visited by Salome*

Canvas, 31⅞ by 38¾ inches, 81 by 97.5 cms.

Collections: Probably Borghese Collection (see below); Lord Radstock (1753–1825); 3rd Marquess of Lansdowne, and by descent until 1930; acquired by the present owner in 1964.

Exhibited: Detroit, Institute of Arts, *Art in Italy 1600–1700*, 1965, No.99; Bologna, Palazzo dell'Archiginnasio, *Il Guercino*, 1968, No.52 (which see for further references).

Literature: Anna Jameson, *Private Galleries of Art*, 1844, p.33; W. Hazlitt, *Criticisms on Art*, 1844, II, Appendix, p.xxi, Art Union, IX, 1847, P.330; G. E. Ambrose, *Catalogue. . . Lansdowne Collection*, 1897, p.40, No.101; Zucchini, *Catalogo Collezioni Comunali d'Arte*, Bologna, 1938, pp.121–23, Fig.25; Erwin Panofsky, *Titian Problems: Mostly Iconographic*, 1969, p.43ff.

The late Professor Panofsky was responsible for identifying the subject of this painting which Mrs Jameson described as follows 'It appears to represent some famous brigand of that (Guercino's) time visited by his wife in his dungeon'. It has on other occasions been identified as *Joseph with Potiphar's Wife* and *Roman Charity*. There was a tradition, which surfaced especially in the nineteenth century but which also existed earlier, of Salome's being in love with the Baptist.

The painting is to be dated to late 1622, or early 1623, by reason of its stylistic affinity with the *Burial of Saint Petronilla*.

We are grateful to Mr. Mahon for providing the following further notes about the provenance of the picture:

It seems probable that the exhibited painting was identical with a picture by Guercino recorded towards the end of the eighteenth century in the first room of the gallery in Palazzo Borghese at Rome as representing 'Roman Charity'. Ramdohr (*Ueber Mahlerei . . . in Rom*, I, p.180) writing in 1787, and giving a description of it which corresponds with the present composition, says that it was commonly called a Roman Charity, but that the subject was doubtful. The year before, in the periodical *Memorie per le Belle Arti* (II, 1786, p.CCXVIII), there appeared a report of an engraving by Pietro Savorelli having just been published of a picture by Guercino in the Borghese Collection 'known under the name of Roman Charity' (the inference being that the subject-matter was questionable); unfortunately no copy of this engraving has as yet been traced. This picture is not to be confused with a painting that has remained in the Borghese collection until the present day and which genuinely represents that subject; this was in the same room as the Guercino, under an erroneous attribution to Veronese, and is now catalogued as Roman School (II, No.148). The Guercino was still recorded in Vasi's guide book of Rome of 1797 (I, p.306), but had disappeared by the 1806 French edition and the 1807 Italian edition; and is worth recalling that No.23 of the Guercino Exhibition of 1968, which had been sold from Palazzo Borghese in 1799, very soon passed

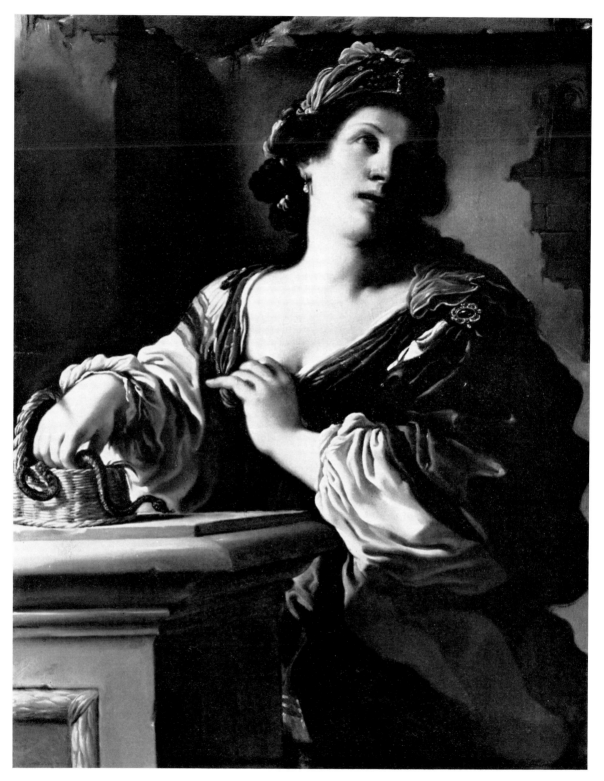

34

into the collection of Lord Radstock (to whom the exhibited picture also belonged). Apart from the copies recorded in the Guercino exhibition catalogue entry (which include one formerly at Forlì, at one time miscalled 'Roman Charity') two more have since come to light: one published by Longhi in Paragone (225, November, 1968, Fig.57) and another sold by auction at Florence on 18 October 1969 (No.136) from the collection of Baronessa Emma Dantoni Camuccini.

Lent by Denis Mahon, Esq., C.B.E.

Giovanni Francesco Barbieri, called Guercino 1591–1666

34 *The Suicide of Cleopatra*

Canvas, 48 by 34 inches, 116 by 92.5 cms

Collections: Thomas Worsley, Hovingham Hall; Sir William Worsley, Bt., by descent.

Exhibited: Bologna, Palazzo dell'Archiginnasio, *Il Guercino*, 1968, No.48.

Literature: *Catalogue of the Pictures at Hovingham Hall*, 1964, p.15.

The painting, which remained unknown until the 1968 exhibition, has all the fluidity of Guercino's work immediately preceding his visit to Rome in 1621/23. But the light and shade contrasts, and the firm contours, are those of works executed in Rome, notably the ceiling decorations in the Casino Ludovisi and the Palazzo Costaguti, suggesting this was painted in late 1621. In the fresco decorations Guercino was making some experiments with his media, and this is also the case with this Cleopatra, where the rough support is itself used to visual effect. In style, it looks forward to the great ceiling canvas of S. Crisogono (now at Lancaster House), which was painted in the middle of the following year.

Lent by the Norton Simon Foundation, Los Angeles.

Giovanni Francesco Barbieri, called Il Guercino 1591–1666

35 *The Presentation at the Temple*

Copper, 28⅛ by 25 9/16 inches, 72·5 by 65 cms

Collections: Painted in Cento soon after Guercino's return from Rome in 1623, for Bartolomeo Fabri; returned to the artist's own possession in part payment of a debt; acquired from the artist by the Frenchman Raphael Trichet Dufresne in 1660; Abbé Francois de Camps (cf. Edmond Bonnaffé, *Dictionnaire des Amateurs Français du XVIIième siècle*, 1884, p.49); Duc d'Orléans (before 1727); sold in England with the Orléans Collection, 1798/99, bought by Lord Gower; bought from him by the 2nd Earl of Ashburnham between 1800 and 1803; sent to auction 20 July 1850, Lot 81, bought in; acquired by the present owner, 1953.

Exhibited: Royal Academy, *Italian Art and Britain*, 1960, No.373; Agnew's, *Art Historians and Critics as Collectors*, 1965 No.11; Bologna, *Il Guercino*, 1968, No.53.

Literature: C. C. Malvasia, *Felsina Pittrice*, 1678, II, p.366; 1841 ed., II, p.26off.; Dubois de Saint Gelais, *Description des Tableaux du Palais Royal*, 1727, pp.225ff., A. Dezallier d'Argenville, *Abrégé . . . des . . . Peintres*, 1745, I, p.298, *Voyage Pittoresque de Paris*, 1749, p.66; Charles Rogers, *A Collection of Prints in Imitation of Drawings*, 1778, II, p.103; *Galerie du Palais Royal*, 1786 (engraved); J. A. Calvi, *Notizie della Vita e Opere di . . . Guercino*, 1808, pp.21, 153, 163; W. Buchanan, *Memoirs . . .*, 1824, I, p.106; D. Mahon, *Studies in Seicento Art and Theory*, 1947, p.93ff., Fig.37; The Connoisseur, 132, 1953, p.110.

Painted shortly after Guercino's return to Cento, this picture begins a completely new stylistic phase. The overall lighting, and the clear definition of planes, show the artist's study in Rome of examples of classical composition. By comparison with the classical tradition of Annibale Carracci and Domenichino, he had found his expressive chiaroscuro style out of fashion. Domenichino himself was in a powerful position, supported by his patron G. B. Agucchi (see No.24) who at the election of Gregory xv in 1621 had become Secretary of State, and who was to some extent the author of the classical theory of painting (cf. Mahon, *loc. cit*). The result in this painting is a highly successful compromise between his own North Italian origins and the classicism of Domenichino and the Roman milieu. That Guercino himself judged it so is illustrated by the fact that he kept it in his bedroom until he was eventually persuaded to part with it in 1660.

Lent by Denis Mahon, Esq., c.b.e.

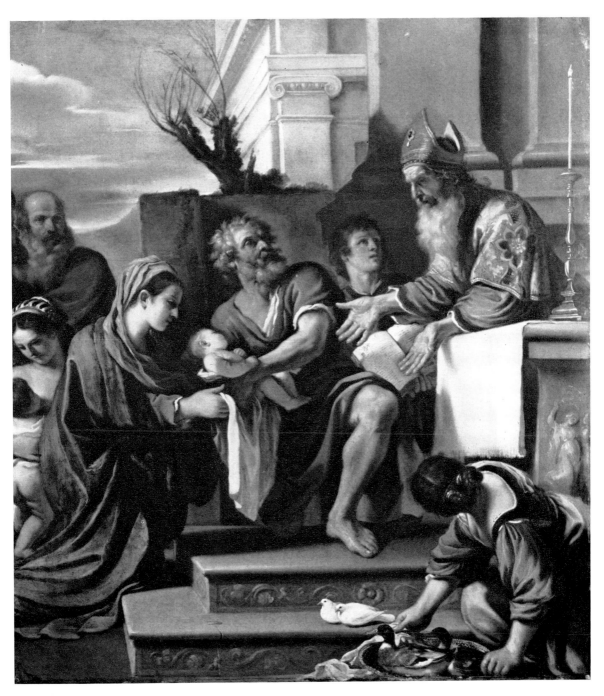

35

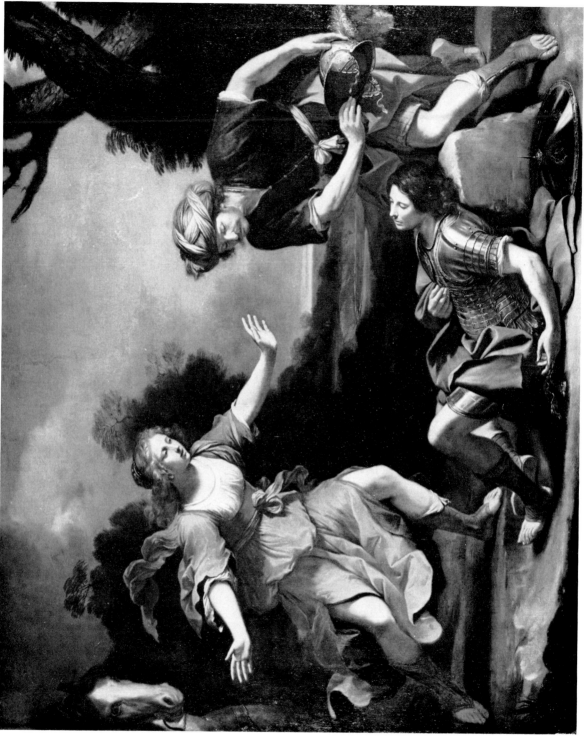

Giovanni Francesco Barbieri, called Il Guercino 1591–1666

36 *Erminia Finding the Wounded Tancred*

Canvas, 98 by 113 inches, 244 by 287 cms.

Collections: Commissioned by Cardinal Fabrizio Savelli in 1649/50, but bought from the artist by the Duke of Mantua (paid for by May 6, 1652); Comte de Lauraguais, France; his Sale (Anon.), Christie's 27 (–29) February 1772, No.70, bought for the 5th Earl of Carlisle, and by descent at Castle Howard.

Exhibited: Bologna, Palazzo dell'Archiginnasio, *Il Guercino*, 1968, No.88.

Literature: [R. J. Sullivan], *Observations made during a Tour through parts of England, Scotland and Wales*, 1780, p.183; [5th Duke of Rutland] *Travels in Great Britain, Journal of a Tour to the Northern Parts of Great Britain*, 1813, ed., p.95; G. F. Waagen, *Works of Art and Artists in England*, 1838, III, p.208, No.112.

The subject is taken from Tasso's *Gerusalemme Liberata*, Canto XIX, 104:

> Al nome di Tancredi ella veloce
> accorse, in guisa d'ebbra e forsennata.
> Vista la faccia scolorita e bella,
> non scese no, precipitò di sella.

The painting was one of the revelations of the Guercino exhibition in Bologna. In contrast to the earlier works by Guercino shown in this exhibition, its delicate harmony is based on idealized form and on the subtle play of colour. The direction of idealization was one which Reni also took, but instead of the abstract distillation of his forms, Guercino retained a romantic outlook, which emanates from the entrancing detail and the landscape background.

Lent from the Castle Howard Collection.

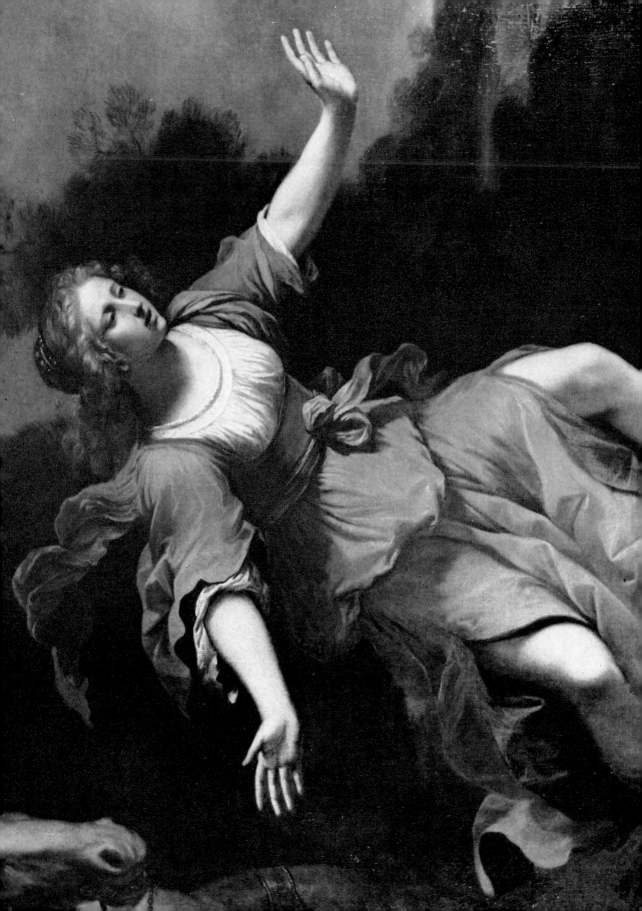

Giovanni Francesco Barbieri, called Il Guercino 1591–1666

37 *The Cumaean Sibyl, with a Child Angel*

Canvas, 87⅜ by 66⅜ inches, 222 by 168·5 cms

See Cover illustration

Collections: Commissioned by Gioseffo Locatelli of Cesena, but probably purchased from Guercino by Prince Mattias de Medici, in 1651; acquired for Fintray House, Aberdeen, by Sir John Forbes, 7th Bt.; by descent to Lord Sempill; acquired by the present owner in 1954.

Exhibited: Rome, *Seicento Europeo*, 1956/57, No.125, Pl.44; Manchester, City Art Gallery, *European Old Masters*, No.135; Royal Academy, *Italian Art and Britain*, 1960, No.386; Bologna, *Il Guercino*, 1968, No.90 (which see for full history).

Literature: H. Honour, The Connoisseur, 139, 1957, pp.34–35, Pl.IV; D. Sutton, Burlington Magazine, 99, 1957, p.115; E. K. Waterhouse, *Italian Baroque Painting*, 1962, p.116, Fig.99.

The painting shown here was probably ordered from Guercino by Gioseffo Locatelli of Cesena, who eventually received the *Samian Sibyl* and *King David* (both of similar dimensions) which have been, since Gavin Hamilton acquired them for John, 1st Earl Spencer, at Althorp. The theme was one favoured by artist and patrons alike, and its refinement illustrates the advance of art for art's sake in the Seicento. The composition of this painting rests principally on its formal unity, but it could well be described as the ultimate combination of *disegno* and *colore*, the marrying of the Venetian tradition with the classical one. Works by Guercino of this late period (the 1650s) were particularly influential in England, both as regards the early neo-classical painters, and for portraiture, notably that of Reynolds.

Lent by Denis Mahon, Esq., C.B.E.

Giovanni Lanfranco 1582–1647

38 *Adoration of the Shepherds*

Canvas, 48 by 70 inches, 124·6 by 179.2 cms

Collections: Painted for the Marchese Clemente Sannesi, Rome, in about 1606/07; by family descent to the Marchese Uldorico Orsini de Cavalieri, from whom acquired in 1802 by Pietro Camuccini; sold with the rest of the Camuccini Collection to the 4th Duke of Northumberland, 1856.

Exhibited: British Institution, Old Masters, 1859, No.43.

Literature: G. P. Bellori, Vite, 1672, pp.339/40; G. F. Waagen, *Treasures of Art . . .* , IV, Supplement, 1857, p.465; G. B. Passeri, *Vite*, ed. J. Hess, 1934, p.141, n.2; E. Schleier, *Lanfranco's 'Notte' for the Marchese Sannesi and some early Drawings*, The Burlington Magazine, 104, 1962, p.246ff (which see for full history); E. Borea, *Domenichino*, 1965, p.147; D. Posner, *Annibale Carracci*, 1971, Vol.II, p.48; Hugh Brigstocke, Burlington Magazine, 115, 1973, p.526.

In 1607 Lanfranco and Badalocchio dedicated to Annibale Carracci a series of prints after the Old Testament scenes in the Vatican Logge by Raphael and his school. In the dedication they speak of Annibale's illness (which struck him in 1604/5 and from which he never really recovered) as having interrupted their usual study of his works. That the whole studio drew direct inspiration from Annibale's paintings, in retrospect as well as during their creation, is attested to by the surviving drawings and paintings. Many of the individuals were involved in completing commissions that Annibale had started; the separate characters of each hand were to a certain extent overshadowed by this corporate activity. It was Annibale who suggested Lanfranco's name to the Marchese Vincenzo Sannesi, who with his brother Cardinal Jacopo Sannesi were at the peak of their fortunes at the beginning of the papacy of Paul V (1605). It was therefore natural for Lanfranco to paint an Annibalesque composition for Marchese Sannesi; the *Adoration of the Shepherds* is of interest too because several of his contemporaries also painted versions of Annibale's original.

Annibale's original is in fact lost, but the composition, which must date from 1598/99, is known through a copy by Domenichino (formerly in the Dulwich College Art Gallery) now in the National Gallery of Scotland, Edinburgh. Lanfranco's picture is a horizontal adaptation of this upright composition, and his friend Badalocchio also painted a horizontal *Adoration* (now in Bari) as well as an upright picture (now in the Palazzo Patrizi, Rome; exhibited Bologna, *Maestri del Seicento Emiliano*, 1959, No.121).

While we know that Annibale made his painting in emulation of Correggio's *Notte* (Gemäldegalerie, Dresden), Domenichino's copy shows a more classical and formal composition. Lanfranco's reliance on light and colour, with far richer contrasts, illustrates the direction his art was already taking.

A drawing by Lanfranco for the group of the Virgin and Child is in the Uffizi (E. Schleier, *loc. cit.*, Fig.22)

Lent by the Duke of Northumberland K.G., T.D.

Pier Francesco Mola 1612–1666

39 *The Rest on the Flight into Egypt*

Copper, 9 by 11 inches, 22.9 by 28 cms.

Collection: in the Lansdowne Collection by 1854.

Exhibited: Royal Academy, *Old Masters*, 1884, No.259; Agnew's, *Loan Exhibition of the Lansdowne Collection*, 1954/55, No.49.

Literature: G. F. Waagen, *Treasures of Art . . .*, 1854, Vol.III, p.158; The Athenaeum, 2 February, 1884, p.157; G. E. Ambrose, *Catalogue . . . Lansdowne Collection*, 1897, No.141; R. Cocke, *Pier Francesco Mola*, 1972, pp.17, 44, 70, No.3, Pl.25.

Bolognese painting was a formative influence in Mola's art; the two paintings shown in this exhibition illustrate different facets of this inspiration. Although Richard Cocke has cited this *Rest on the Flight* as an instance of a work whose Albanesque derivation would point to its having been painted in Bologna (and thus in the period 1645/47) the derivation is as much from Badalocchio's work of the Roman period, and the jewel-like colouring of Domenichino's landscapes. Already early in the seventeenth century the cabinet pieces of Annibale and his circle were copied and imitated: Bellori for example refers (*Vite*, 1672, p.112) to a small copper by Annibale formerly in the Villa Montalto 'copiandosi di continuo, già si consumava nelle mani de' copisti'.

Lent by the Marquess of Lansdowne.

Pier Francesco Mola 1612–1666

40 *The Return of the Prodigal Son*

Canvas, 88 by 58½ inches, 219·5 by 148.5 cms.
Exhibited: Royal Academy, *Old Masters*, 1881, No.157 (as by Guercino).
Literature: G. F. Waagen, *Treasures of Art . . .*, 1854, Vo.III, p.15.

The chronology of Mola's work is still problematic, and this work was not known in the original to Richard Cocke prior to the publication of his recent monograph on the artist. But the painting would date from a Guercinesque moment in his career, and in the nineteenth century it was indeed exhibited as being by that hand, inducing the Athenaeum's reviewer to observe 'The Prodigal Son by Guercino is one of the finest oil pictures of that unequal painter, who living in a degenerate age never did his powers justice'. Another *Prodigal Son* (Vitale Bloch Collection: exhibited Wildenstein's, *Artists in Seventeenth Century Rome*, 1955, No.56), also shows a Guercinesque influence, although the figure has an entirely different pose. It might perhaps however be tentatively suggested that the figure of the Prodigal does relate to that of the kneeling monk in the altarpiece (of comparable scale to the present picture) *The Image of St. Dominic carried to Soriano* (Rome, SS. Domenico e Sisto; R. Cocke, *op. cit.*, Pl.35) which is documented to 1647/48.

Lent anonymously.

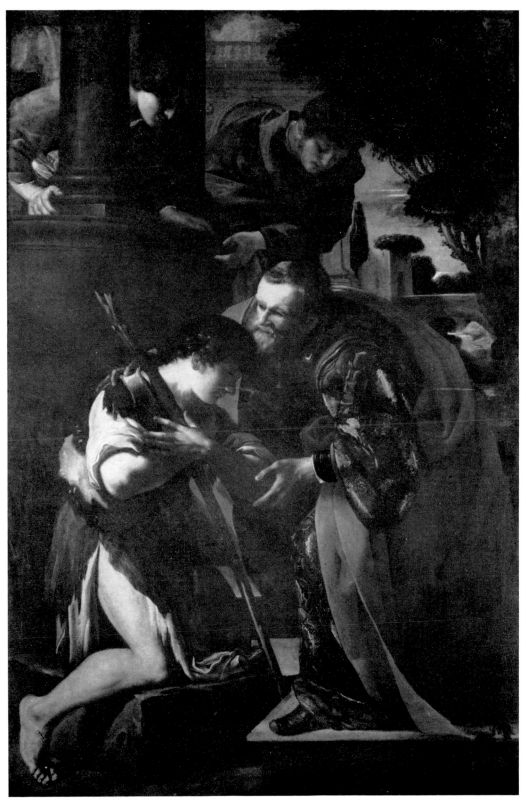

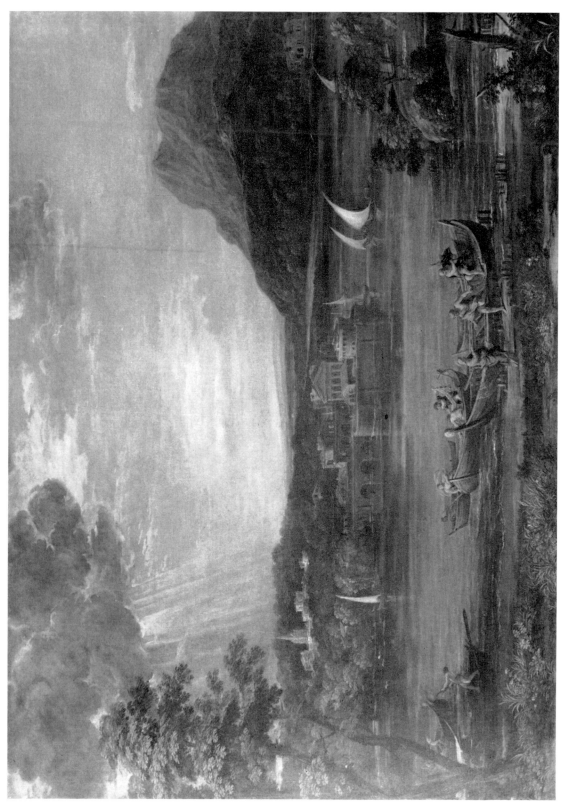

Pietro da Cortona 1596–1669

41 *The Calling of St. Peter and St. Andrew*

Canvas, 46¼ by 66 inches, 117·5 by 167·7 cms

Collection: 4th Duke of Devonshire (by 1761) and by descent.

Exhibited: British Institution, *Old Masters*, 1837, No.78; Royal Academy, *Holbein and other Masters*, 1950/51, No.458; on loan to Manchester City Art Galleries from 1951 onwards.

Literature: S. Dodsley, *London and its Environs*, 1761, II, p.227; G. F. Waagen, *Treasures of Art . . .* , 1854, Vol.II, p.92; G. Briganti, *Pietro da Cortona*, 1962, p.181, No.25, Pl.98; J. W. Goodison & G. H. Robertson, *Catalogue of Paintings* (Fitzwilliam Museum), Vol.II, 1967, p.41.

Engraved: by Chatelin and Vivarès for Boydell after a drawing by J. Goupy.

Painted towards the end of the 1620s, this landscape illustrates the influence of Bolognese landscape painting, and particularly that of Domenichino. It is closely linked with a fresco of the same subject (for which the Fitzwilliam Museum in Cambridge have recently acquired the *modellino*) that Pietro da Cortona painted in the chapel of the Villa Sacchetti at Castel Fusano between 1626 and 1630.

In this landscape, which contains classical elements in the form of the town by the Lake of Galilee, there is perhaps a conscious echo of actual classical paintings, just as in Polidoro da Caravaggio's landscapes in San Silvestro al Quirinale, Rome (among the very few surviving of what must have been a flourishing sixteenth century tradition). Seventeenth century writers were conscious of the new naturalism introduced by the Bolognese painters, although they are less articulate about the principles of composition employed by Annibale Carracci and Domenichino. This work evidently combines many of their devices with an observed naturalism; as a separate composition, it is more articulated and self-sufficient than the fresco at the Villa Sacchetti.

From the Devonshire Collection, Chatsworth: Lent by the Trustees of the Chatsworth Settlement.

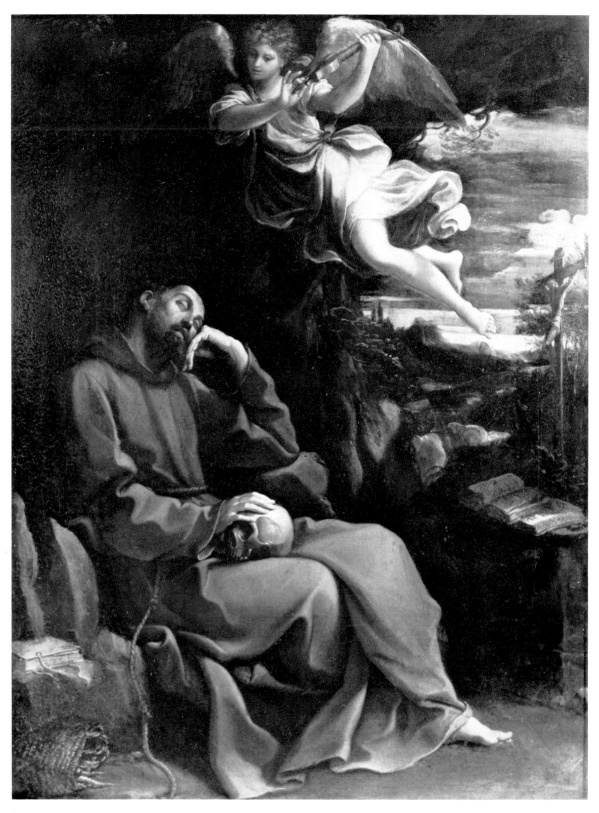

Guido Reni 1575–1642

42 *The Vision of St. Francis*

Collection: Acquired by the present owner in 1951.

Exhibited: Manchester, City Art Gallery, *European Old Masters*, 1957, No.88 (as by Annibale Carracci); Royal Academy, *Italian Art and Britain*, 1960, No.399 (also as by Annibale).

Literature: G. Briganti, *The Mahon Collection of Seicento Paintings*, The Connoisseur, 133, 1953, p.5, Figs.11, 16; Denis Mahon, Gazette des Beaux-Arts, 1957, p.277; R. Longhi, Paragone, No.125, May 1960, Pl.44; P. Matthiesen & D. Stephen Pepper, *Guido Reni, An Early Masterpiece discovered in Liguria*, Apollo, 91, 1970, p.462; n.45; D. Posner, *Annibale Carracci*, 1971, Vol.II, p.81, No.195(R); C. Garboli and E. Baccheschi, *L'Opera Completa de Guido Reni*, 1971, No.39.

Attributed initially to Annibale Carracci, this painting was given to Reni by Longhi in 1960, and this attribution has now been generally accepted. A work dated by Stephen Pepper to around 1606–7, the forms are naturally Annibalesque in character. In composition, it derives also from Agostino Carracci's engraving of the same subject (Bartsch, XVIII, No.67) which is only partially based on a painting by Francesco Vanni.

Lent by Denis Mahon, Esq., C.B.E.

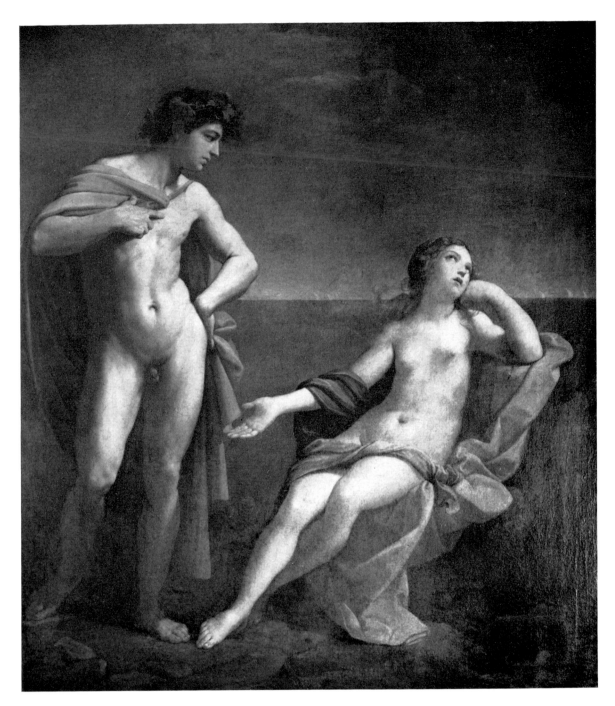

43

Guido Reni 1575–1642

43 *Bacchus and Ariadne*

Canvas, 39 by 34 inches, 99 by 86 cms.

Collection: Cardinal Montalto (see below) by 1678.

Literature: C. C. Malvasia, *Felsina Pittrice*, 1841 ed., Vol.II, p.64; G. F. Waagen, *Treasures of Art . . .* , 1854, Vol.III, p.393; F. G. Stephens, The Athenaeum, Aug. 8, 1874, p.184.

This unknown painting is probably the one that was described by Malvasia as being in the Vigna Peretti (which belonged to Cardinal Montalto). 'Arianna, che nuda sede sopra uno scoglio, e Bacco che seco discorre.' The same author refers several other times to works of this subject, one painted for Luigi Zambeccari (p.33) another given to Sig. Ippolito Boncompagni in Rome (p.52), and another owned by Sig. Davia, in which the Bacchus is a portrait of the painter Savonanzi (p.57). Reni's most famous rendering of the theme was the lost work completed in 1640, commissioned in collaboration with Albani as a gift to the Queen of England. This much earlier work, painted around 1619/20, illustrates Guido's refinement of classical subject-matter that excludes superfluous detail, just as in the later *Bacchus and Ariadne* he was to eliminate the verdant landscape that Albani painted as a background to his figures.

Lent by the Viscount Scarsdale, T.D.

Guido Reni 1575–1642

44 *Crucifixion*

Canvas, 38 by 29 inches, 96·5 by 74·9 cms.

Collections: until 1801 in the Chapel of Cardinal Berlinghieri Gessi, Santa Maria della Vittoria, Rome; bought from the church by Pietro Camuccini; acquired with the Camuccini collection by the 4th Duke of Northumberland, 1856.

Exhibited: British Institution, *Old Masters*, 1856, No.52; Royal Academy, *Holbein and other Masters*, 1950/51, No.326; Bologna, Palazzo dell'Archiginnasio, *Guido Reni*, 1954, No.32 (see the catalogue for further references).

Literature: F. Titi, *Pitture . . . in Roma*, 1674, p.333; C. C. Malvasia, *Felsina Pittrice*, 1678, II, p.30 (1841 ed., II, p.22, n.2); A. Nibby, *Roma nell'anno MDCCCXXXVIII*, Rome 1839, Pt.I, pp.530/31; G. F. Waagen, *Art Treasures . . .*, IV, Supplement, 1857, p.470; G. B. Passeri, *Vite . . .*, ed J. Hess, 1934, p.353; G. P. Bellori, *Vite di Guido Reni, Andrea Sacchi e Carlo Maratti*, Rome, 1942, p.29; Denis Mahon, *The Seicento at Burlington House, II*, The Burlington Magazine, Vol.93, 1951, p.78; G. C. Cavalli and C. Gnudi, *Guido Reni*, 1955, No.64, Pl.118; C. Garboli and E. Baccheschi, *L'Opera Completa de Guido Reni*, 1971, No.133.

As Denis Mahon noted (*loc. cit.*), Malvasia states that this picture was painted for Cardinal Gessi, who later left it in his will to his chapel at S. Maria della Vittoria when he died in 1639. The painting is mentioned in the early sources as a version of the *Crucifixion* that Reni painted for the Church of the Cappuccini in Bologna (now in the Pinacoteca Nazionale, Bologna); but this painting omits the figure of the Magdalen and differs in many other particulars. The composition was highly influential for the iconography of the Crucifixion in the seventeenth century and later, while details such as the head of the Virgin became the subject of separate works both in Guido's own studio and in the industry of devotional images. This painting from Alnwick is dated to around 1625/26 by Stephen Pepper.

Lent by the Duke of Northumberland, K.G., T.D.

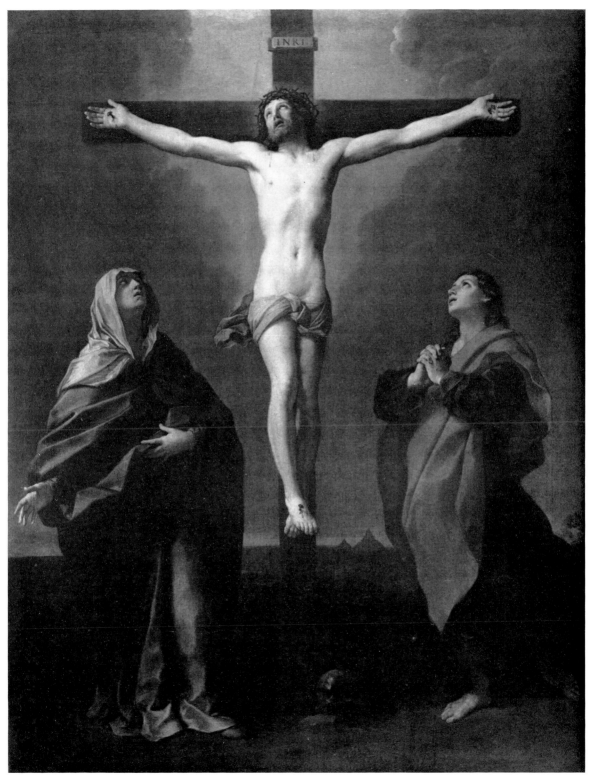

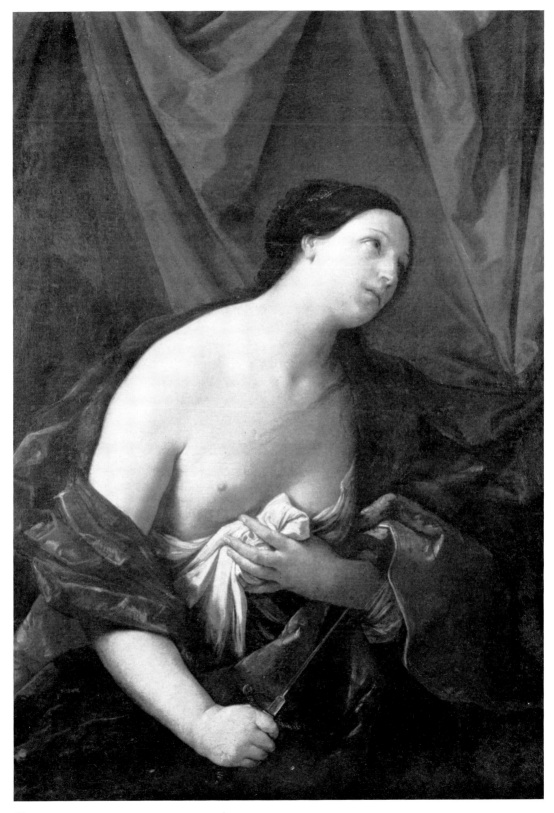

45

Guido Reni 1575–1642

45 *Lucretia*

Canvas, 50¼ by 39 inches, 128 by 99 cms.
Collection: Acquired by the Duke of Wellington in 1821 from George Hayter
(later Sir George) for £210.

Previously unpublished, this painting is wonderfully preserved and exquisite in
quality. It certainly dates from around 1625/27, as is evidenced by the deep
colouration and the sharp, precise folds in the drapery. It was recognized at
Apsley House by Mr Denis Mahon, to whom the late Duke of Wellington con-
veyed the information about its provenance. When purchased in 1821 (the subject
then described as *Arria*) it was said to have come from Rome. Malvasia (*Felsina
Pittrice*, 1841 ed., Vol.II, p.65) mentions a half-length *Lucretia* in the Grand Duke's
collection in Florence, but it is not so far possible to determine if this refers to the
present picture.

Lent by the Duke of Wellington, M.V.O., O.B.E., M.C.

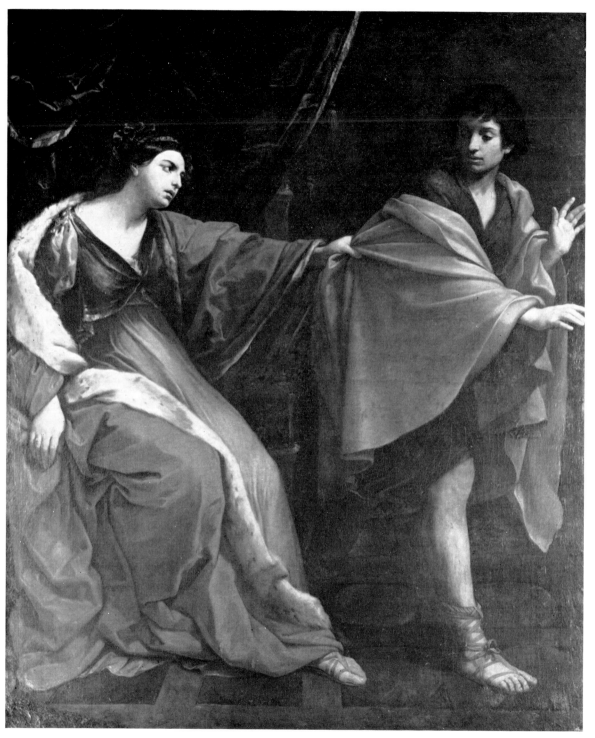

46

Guido Reni 1575–1642

46 *Joseph and Potiphar's Wife*

Canvas, 87 by 74 inches, 221 by 188 cms.

Collection: Palazzo Costaguti, Rome; at Holkham by 1817.

Literature: T. W. Coke, *A Stranger's Guide to Holkham*, 1817, p.107, No.185.

This is possibly the 'gran quadrone del Gioseffo' referred to Malvasia. He refers to paintings of this subject by Guido Reni three times (*Felsina Pittrice*, 1841 ed., II, pp.60, 63, 65). On p.63 he refers to one in the Pasinelli collection in Bologna, later owned by Senator Ghisilieri; an early eighteenth century note by Zanotti (printed in the 1841 ed.), records that it was then owned by Cardinal Ruffo. This version is mentioned in Ruffo's collection of 1734 (Jacopo Agnelli, *Galleria di Pitture . . . Cardinal Tommaso Ruffo, Vescovo di Palestrina e di Ferrara*, Ferrara, 1734, pp.40–41), and its dimensions are given as 6 by 7 *palmi* (equivalent to about 132 by 154 cms). A painting corresponding to these proportions showing three-quarter length figures was engraved by Robert Strange in 1762 when it was in the Palazzo Baronelli, Naples to which other pictures belonging to Cardinal Tommaso Ruffo are known to have passed. Also on p.63 Malvasia refers to a painting in the gallery of the 'Marchese, Gran Croce and Senator Cospi' – *il gran quadrone del Gioseffo*. On p.60, and again on p.65, Malvasia mentions a work belonging to Cardinal Giovanni Carlo, Prince of Tuscany, and in the second reference, to 'le Serenissime Altezze' in Florence. It is related that when Cardinal Giovanni Carlo called upon Pietro da Cortona (who died in 1669) to sort out the best of the paintings in the collection to hang in his palace in Florence, the *Joseph and Potiphar's Wife* by Guido was relegated to a garden pavilion, which much shocked Angelo Michele Colonna and Scaramuccia, who voiced their disapproval. The Marchese Balì Cospi is known to have made purchases on behalf of the Medici in Bologna (for instance, No. 37 in this exhibition; see *Il Guercino* catalogue, 1968, p.196) and Malvasia does in fact refer to him as an agent for the Grand Duke of Tuscany (1841 ed., II, p.336), and so it is possible that the painting from the Cospi collection was also the one mentioned by Malvasia as being in Florence. This is borne out also by the statement in Giordani (*Cenni . . .*, 1840, p.48, n.54) that the Cospi picture was sent to Florence.

A second version of the Holkham painting exists in the Pushkin Museum in Moscow, and comes from the Vorontsov-Dashkov collection (227 by 195 cms, repr. in C. Garboli & E. Baccheschi, *L'Opera Completa di Guido Reni*, 1971, p.106 No.148; illustration reversed). Mr Pepper has not seen this version on account of its location in the stores of the Museum, but on the basis of a photograph he feels justified in considering it a copy.

The date of the painting must be about 1626; the tight brilliance of the folds of the drapery and garments and the dark saturated tonality point to this moment in Reni's career. The painting must have influenced Cantarini, whose style it resembles, and the latter's painting in Dresden is based on the composition of the work engraved by Strange.

Lent by the Trustees of the Earl of Leicester, M.V.O.

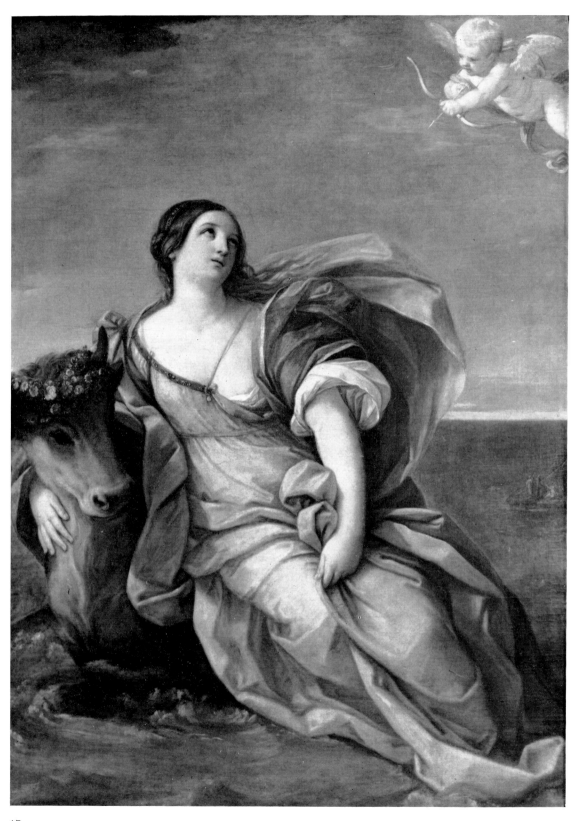

Guido Reni 1575–1642

47 *The Rape of Europa*

Canvas, 68½ by 50¾, 174 by 129 cms

Collections: acquired in 1741 by Sir Jacob de Bouverie (afterwards 1st Viscount Folkestone, and father of the 1st Earl of Radnor) from Samuel Paris, importer of pictures from the Continent; remained in the Radnor collection at Longford Castle until 1945, when acquired by the present owner.

Exhibited: Bologna, *Guido Reni*, 1954, No.53; Manchester, City Art Gallery, *European Old Masters*, 1957, No.127; Royal Academy, *Italian Art and Britain*, 1960, No. 397.

Literature: G. F. Waagen, *Treasures of Art*, IV, Supplement, 1857, p.359; D. Mahon, *Studies in Seicento Art and Theory*, 1947, p.51, Fig.17; G. Briganti, *The Mahon Collection of Seicento Paintings*, The Connoisseur, 132, 1953, pp.7–8, 16, Fig.XVII, Cat. No.40; D. Sutton, Country Life, 116, 16 Sept. 1954, pp.898/99, Fig.4; H. Honour, The Connoisseur, 134, 1954, p.268; C. Gnudi and G. C. Cavalli, *Guido Reni*, 1955, pp.87–88, Pl.146; O. Kurz, *Bolognese Drawings . . . at Windsor Castle*, 1955, p.127; F. M. Godfrey, *Later Italian Painting, 1500–1800*, 1958, pp.342–43; A Emiliani, *Mostra dei Disegni del Seicento Emiliano nella Pinacoteca di Brera*, 1959, p.31 (under No.8); C. Garboli & E. Baccheschi, *L'Opera Completa di Guido Reni*, 1971, No.164a & Colour plate LIV.

According to Malvasia, Reni painted three versions of the Rape of Europa; one for Charles I of England, another for the Conte di Guastalla acting on behalf of a Spanish patron, and another for the King of Poland (who thanked the artist for the painting in a letter of 1640). It is not possible to identify the present picture securely with any of these; in style, it dates from the period 1634–37. A number of copies are listed in the 1960 Royal Academy catalogue entry.

Lent by Denis Mahon, Esq., C.B.E.

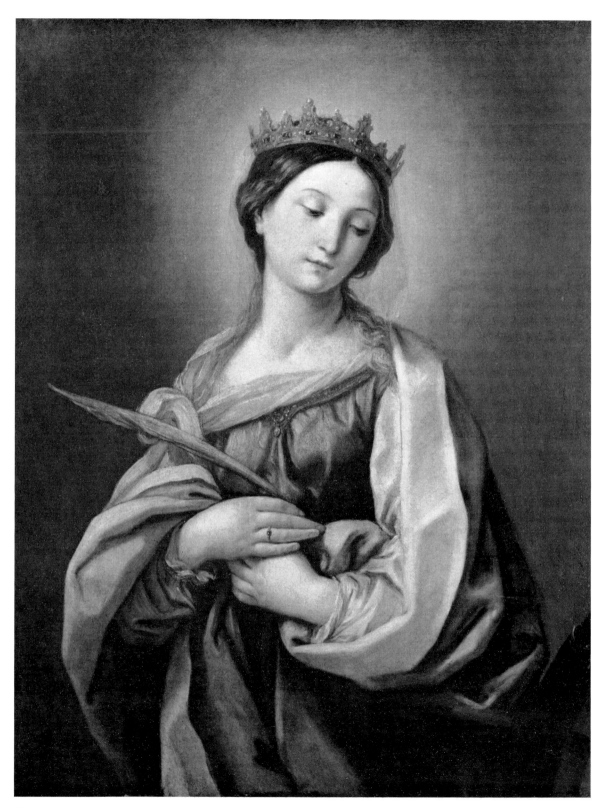

48

Guido Reni 1575–1642

48 *St. Catherine*

Canvas, 41 by 33½ inches, 104·2 by 85·1 cms.

Collections: Contestabile Colonna, Rome (1678); in Paris, 1769, where bought by Robert (later Sir Robert) Strange; H. Farrer; an English Private Collection, by 1839.

Exhibited: British Institution, *Old Masters*, 1839, No.45.

Literature: C. C. Malvasia, *Felsina Pittrice*, 1841 ed., p.64; Marcello Oretti, *Notizie de' Professori* . . . , 1780 c., Biblioteca Comunale di Bologna, MS126, p.251; Robert Strange, *Catalogue of a Collection of Pictures* . . . , London, 1769, p.58; P. J. Mariette, *Abecedario*, Vol.IV, in Archives de l'Art Francais, VIII, p.374; *European Museum*, including the Collection of Sir Robert Strange, 1818, No.256.

Engraved: by Pierre Daret (1604–1678); a drawing for an engraving after this picture by Robert Strange (1721–1792) is in the British Museum, BM1861–1–12 108; but no copy of the engraving has as yet come to light; also engraved in 1818 in the European Museum and by Albert, London, 1831.

This rediscovered late masterpiece by Guido was according to Malvasia (*loc. cit.*) one of a pair of female saints belonging to Contestabile Colonna in Rome, and is likely to have been acquired direct from the artist or his heirs by Cardinal Girolamo Colonna, when Archbishop of Bologna between 1632 and 1645. Strange, who purchased the painting in Paris in 1769, is reported by Mariette as being under the impression that it was by Domenichino. When however the former published his Catalogue in London later in 1769, he had evidently pursued the provenance further, since he mentions the companion to the *St. Catherine*, a *St. Margaret*, as being still in the Palazzo Colonna.

Without being as chalky in consistency as some of the late Reni's, this *St. Catherine* epitomizes the simplicity of form combined with extreme subtlety of colouring, that is the final refinement of his style. A recent cleaning revealed multiple *pentimenti*, some of which are visible to the naked eye. The work is dated by Stephen Pepper to around 1638.

Lent anonymously.

Guido Reni 1575–1642

49 *Liberality and Modesty*

Canvas, 110 by 76 inches, 280 by 193 cms

Collections: Probably painted for Alessandro Sacchetti; Robert Furnese; Henry Furnese (by 1755); his sale, 3 February, 1758 (not in catalogue), bought by John Spencer, later 1st Earl Spencer (£2200 together with Andrea Sacchi's *Apollo rewarding Merit and punishing Arrogance*) and by descent.

Exhibited: British Institution, *Old Masters*, 1818, No.57; Leeds, *National Exhibition of Works of Art*, 1868, No.197.

Literature: C. C. Malvasia, *Felsina Pittrice*, 1678, IV, p.56; 1841 ed., II, p.42; George Vertue, *Notebooks*, *IV*, Walpole Society, Vol.24, p.164; Horace Walpole, letter to Sir Horace Mann, 9 February, 1758 (ed. P. Cunningham, 1906, Vol.III, p.125); Horace Walpole, *Journals of Visits to Country Seats*, *&.*, ed. P. Toynbee, Walpole Society, XVI, 1927–28, p.14; G. F. Waagen, *Treasures of Art . . .*, 1854, Vol.III, p.21; James Dennistoun of Dennistoun, *Memoirs of Sir Robert Strange*, Knt. . . ., 1855, pp.254, 263; O. Kurz, *Guido Reni*, Jahrbuch der Kunsthistorischen Sammlung in Wien, 1937, p.217; G. Reitlinger, *Economics of Taste*, 1961, p.xiv; C. Garboli and E. Baccheschi, *L'Opera Completa di Guido Reni*, 1971, under No.89a.

Engraved: by Robert (later Sir Robert) Strange, 1755 (in reverse).

Malvasia refers to two versions of the *Liberality and Modesty*; one in the Palazzo Falconieri in Rome (*Felsina Pittrice*, 1841 ed., II, p.64) which was apparently still there in 1770, and another 'La Liberalità e Modestia pel Sig. Alessandro Sacchetti, finite poi tanto bene dal Sirani' (p.42). There were a great number of unfinished canvases in Reni's studio at the time of his death, at various stages of completion, and some were finished for patrons who had in many cases been waiting several years for their commission, by Giovanni Andrea Sirani, the artist's pupil and assistant. The canvas from Althorp must have been at an advanced stage of completion by Reni himself, but it is possible to discern a second hand in some sections; though Malvasia does after all commend the good job that Sirani did in finishing it.

It is not known whether the dealer-engraver Robert Strange, who published a print of the painting in 1755 when it was already in the collection of Henry Furnese, was responsible for importing the painting into England. Henry Furnese had been Lord of the Treasury, and died in 1756. The enormous sum that John Spencer (later 1st Earl Spencer) gave for the painting and another by Sacchi at the Furnese sale in 1758 aroused Walpole's incredulity, especially as he regarded the Reni as of dubious originality. In Strange's day, there was another version in the Palazzo Monti (to which Walpole also refers), which is probably the version later in the Darnley collection (cf. Waagen, *loc. cit.*). Strange himself (J. Dennistoun, *loc. cit.*) regarded the Monti version as a repetition, and the 2nd Earl Spencer in a letter to his mother, of 1785 (preserved at Althorp) thought the Monti painting inferior to this one. There is another version in the Devonshire collection, now hanging in the octagon at Chiswick House, and a full-scale eighteenth century

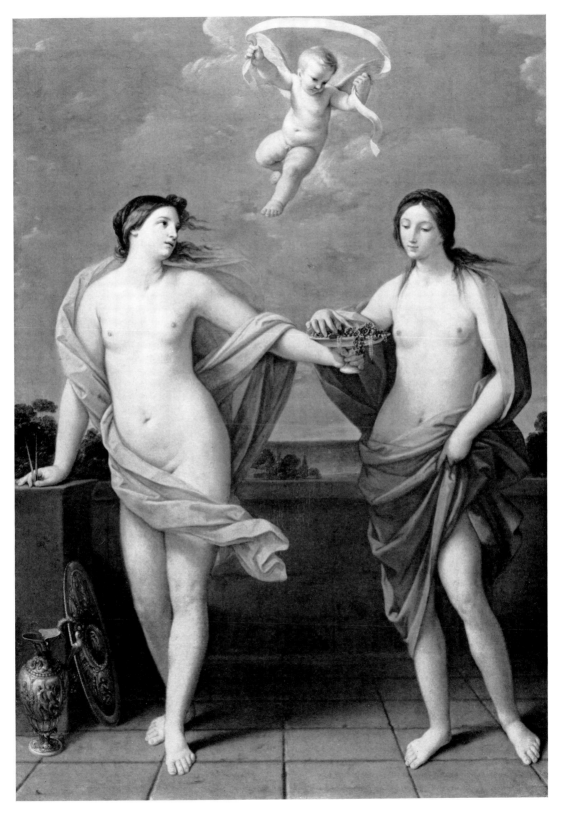

49

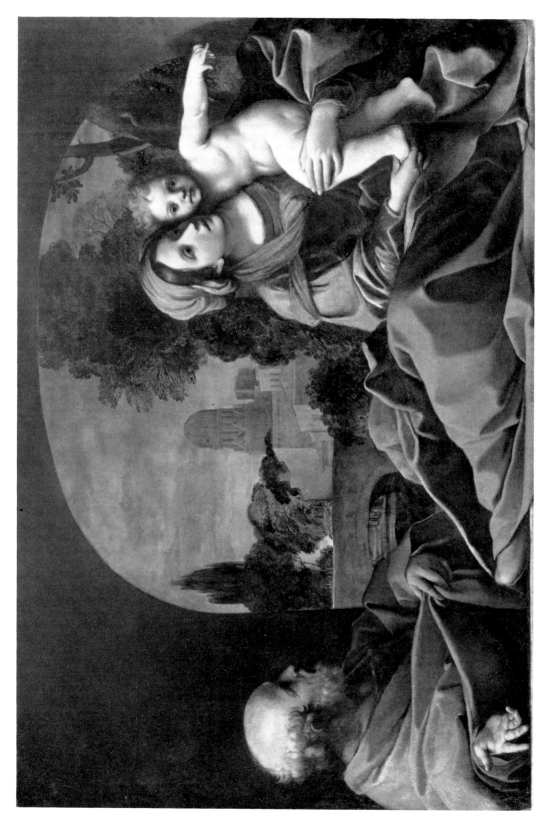

50

copy in another English private collection (where it has been since the eighteenth century).

A copy is in the reserve collection of the Galleria Nazionale di Capodimonte, Naples (illustrated in C. Garboli and E. Baccheschi, *op. cit.*).

A drawing by Guido Reni for the figure of Liberality was apparently in the Sir Edward Poynter sale (April 24–25, 1918); Strange's watercolour copy of the painting was formerly at Panshanger.

Both this painting by Guido and the Andrea Sacchi acquired with it were seen by George Vertue (*loc. cit.*) in Robert Furnese's collection in 1739: "a noble large picture of Temperance and Inocence—two fine figures at length by Guido, another such large picture, of appollo crowning with a chaplet an excellent Musititian by ⟨And. Sacchi⟩." The Sacchi is still at Althorp, and has apparently been enlarged (perhaps by Strange?) to make it a pair with the *Liberality and Modesty*. The Sacchi apparently came originally from the collection of the Marchese Pallavicini, was acquired from his heirs and imported into England before 1730 (L. Pascoli, *Vite . . .*, 1730, I, p.16).

Lent by the Earl Spencer.

Alessandro Tiarini 1577–1608

50 *The Holy Family under an Arch*

Canvas, 39¾ by 74¾ inches, 101 by 190 cms

Collections: Given by Prince Eugène Beauharnais (1781–1824), Viceroy of Italy to the Comtesse de Flahault, who married the 4th Marquess of Landsowne in 1843; thence by descent.

In general there is little in Tiarini of the studied classical form of his Bolognese contemporaries who worked in Rome, but in this case the St. Joseph seems to show some sympathy for Reni. Usually, he aimed for dramatic clarity and powerful composition, such as is to be found in some of Lodovico's larger compositions. His early stay in Florence (1599–1606) in fact reinforced this tendency towards monumental clarity; on his return he became established as one of the most active and talented painters in Emilia, although his best period is limited roughly to 1615–30.

The composition of this work goes back to Lodovico's print *The Holy Family under an Arch* (Bartsch, XVIII, No.4). Following much the same idea is Annibale's *Holy Family at a Window* (Bartsch 11; 1590). This painting must have been conceived in an architectural setting intended to be viewed from below.

Dr J. Winckelmann, who is working on Tiarini at Bologna, has seen a photograph of this painting, which he regards as a major work of around 1625.

Lent by the Earl of Shelburne.

Blockmaking by Gilchrist Bros.
Designed and printed by Lund Humphries